MICHIGAN

OUR LAND, OUR WATER, OUR HERITAGE

~~~

Edited by John Knott

Published in cooperation with
The Nature Conservancy
The University of Michigan Press · Ann Arbor

The Nature Conservancy
Protecting nature. Preserving life.™

Copyright © 2008 by The Nature Conservancy

All rights reserved

Published in the United States of America by

The University of Michigan Press

Manufactured in Canada

∞ Printed on acid-free paper

2011   2010   2009   2008        4      3      2      1

*A CIP catalog record for this book is available from the British Library.*

*Library of Congress Cataloging-in-Publication Data*

Michigan : our land, our water, our heritage / edited by John Knott.

115    p.    cm. ill.

"Published in cooperation with The Nature Conservancy"

ISBN-13: 978-0-472-11641-6 (cloth : alk. paper)

ISBN-10: 0-472-11641-X (cloth : alk. paper)

1. Natural history—Michigan.   2. Rivers—Michigan.   3. Water
resources development—Michigan.   4. Michigan—Description and
travel.   I. Knott, John, 1937–   II. Nature Conservancy.

QH105.M5M555      2008

508.774—dc22                          2007052487

Proceeds from this publication support conservation in Michigan and the Great Lakes.

Designed by Savitski Design, Ann Arbor, Michigan

*Michigan*  OUR LAND, OUR WATER, OUR HERITAGE

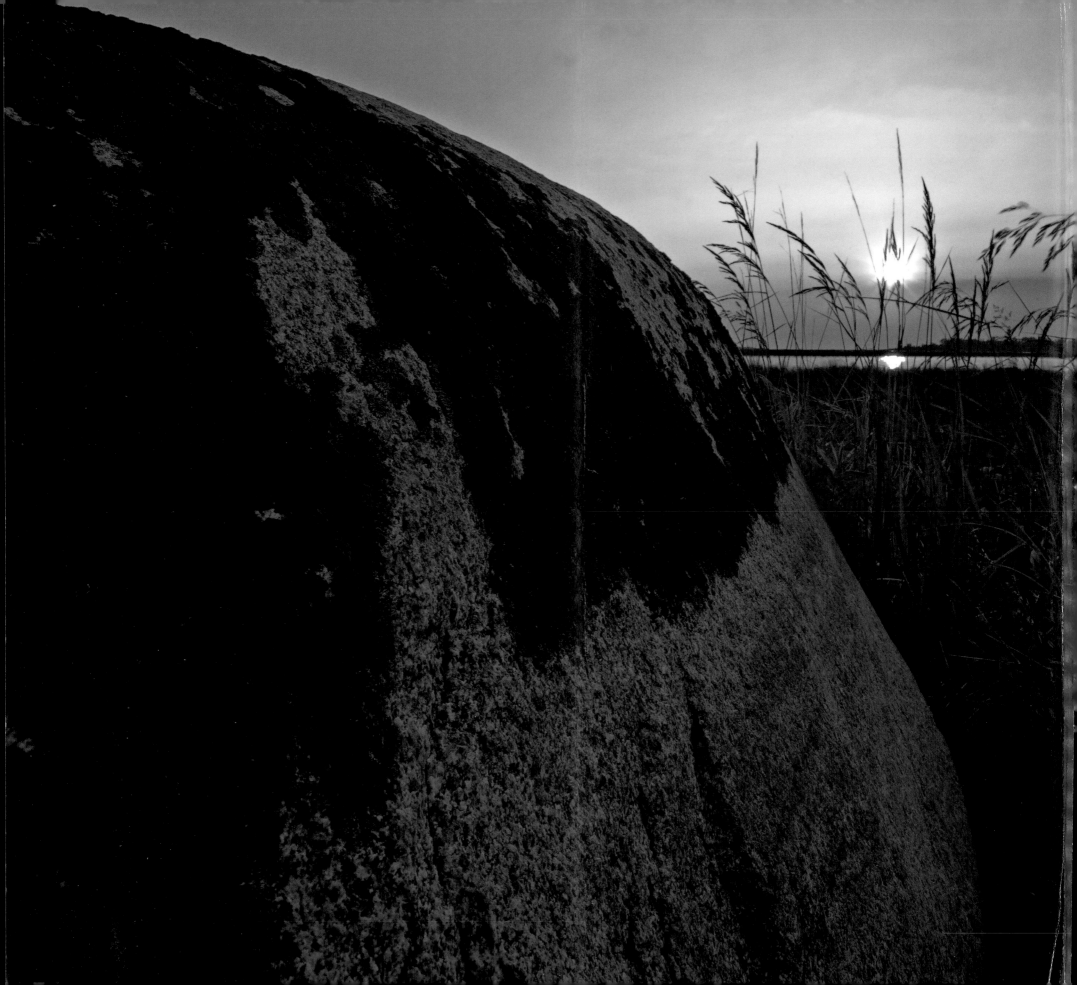

"It's all about connections" you'll hear people say. It *is* true. We are all connected. We are people whose hearts have been captivated by Michigan's forest, water, and shoreline, and our history has been shaped and dominated by them. We belong to a region that provides breathtaking beauty, working lands that sustain us, and a rich culture defined by our relationship with land and water. And we are part of the largest freshwater system in the world, the Great Lakes. Together, we must understand the deep interconnections of the natural world, our culture, our economy, and our future.

The Nature Conservancy is working to protect the plants, animals, and natural habitats that ensure our very existence and enhance our quality of life across the world—and we are all connected by a vision of a world in which forests, grasslands, deserts, lakes, rivers, and oceans are healthy and vibrant; where their connection to the quality of human life is recognized and valued; where places that sustain both nature and people endure for generations. In this beautiful book, you will visit some of these places—places that embody our heritage and will endure because people will continue to act, steward, and understand how to balance the natural, economic, and cultural needs of our communities, the Great Lakes, and the world for the future. Yet each of us connects to places differently, as our writers did, and as you will when you experience the photographs of places that will endure because of The Nature Conservancy's efforts in partnership with so many. The connection to place is a powerful one. I have never had a good answer to the question "What person has inspired you most in your life?" It is places that have had the greatest influence on me and that feeling of connectivity with the world that those places brought me. We *are* all connected by a sense of place in Michigan. It is our land, our water, and our heritage. And we are connected in our responsibility to assure that these places in Michigan, these Great Lakes, endure—five Great Lakes, two countries, and one chance to protect them. ∾

HELEN TAYLOR *Preface*

A project of this nature would be impossible without the efforts not only of the writers and photographers whose work it features but also of a large supporting cast. Members of the staff of The Nature Conservancy consistently found time in very busy schedules to provide essential help. State Director Helen Taylor conceived of the project, found the necessary support, and was its guiding spirit. Melissa Soule was the liaison who opened doors, solved problems, and got photographers to the right places at the right times. She was assisted by Andrea Strach, Will Elkins, Jake Woods, and Carol Navarro, who provided valuable help finding photographs. Cathy Clifford wrote the introductions to each section of the book, and Steve Sobaski prepared the maps. Denise Copen helped everyone stay on time and track things down throughout the process.

The writers and the editor profited greatly from the expertise of field staff who guided them through Conservancy preserves and patiently answered their questions. These included John Legge, Lisa Niemi, and Andrea Kline, as well as Patrick Doran, Doug Pearsall, Jack McGowan-Stinski, Danielle Miller, Rebecca Hagerman, Lara Rainbolt, Craig Burns, Matt Kleitch, Julie Stock, Jeff Knoop, and Steve Woods. Volunteers Nadine Cain, Gina Nicholas, James Diem, and Gary Stock generously shared their knowledge of particular preserves with the writers.

The book benefited from the hard work of many of the talented staff at the University of Michigan Press, including editor Mary Erwin, who offered encouragement, support, and unfailing good sense. Kevin Rennells of the Press played an invaluable role in helping to select photographs for the book, lending his experience and good eye.

There always have to be individuals who believe in the vision behind a project and are willing to provide the support necessary to realize it. Those people are Rick and Sue Snyder, who understood the power of the words and images this book could make available. It would not have happened without them. ∞

*Acknowledgments*

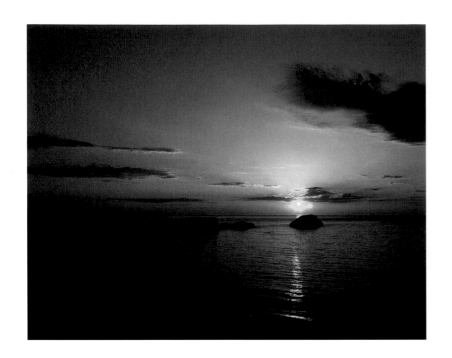

## CONTENTS

Introduction – 1

*Land*

Keith Taylor, *The Nan Weston Preserve at Sharon Hollow* – 13

Howard Meyerson, *Coolbough: An Experience in Land Transformation* – 23

Alison Swan, *Along the Paw Paw* – 31

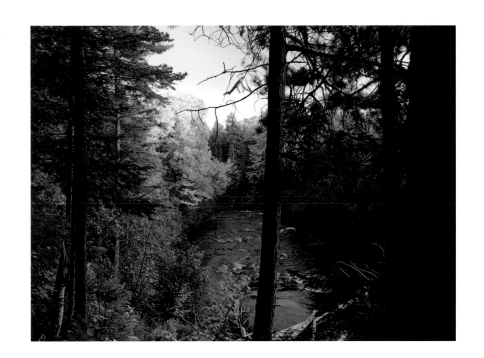

# Water

Anne-Marie Oomen, *Ditches and Rivers* — 45

Jack Driscoll, *In the Heart of the Two Hearted* — 53

# Shoreline

Janet Kauffman, *Erie Marsh* — 67

Elizabeth Kostova, *Journey to Les Cheneaux* — 79

Stephanie Mills, *The Gray Beast: All Wildness and Wet* — 89

Jerry Dennis, *Point Betsie* — 99

Contributors — 107

Photographic Credits — 111

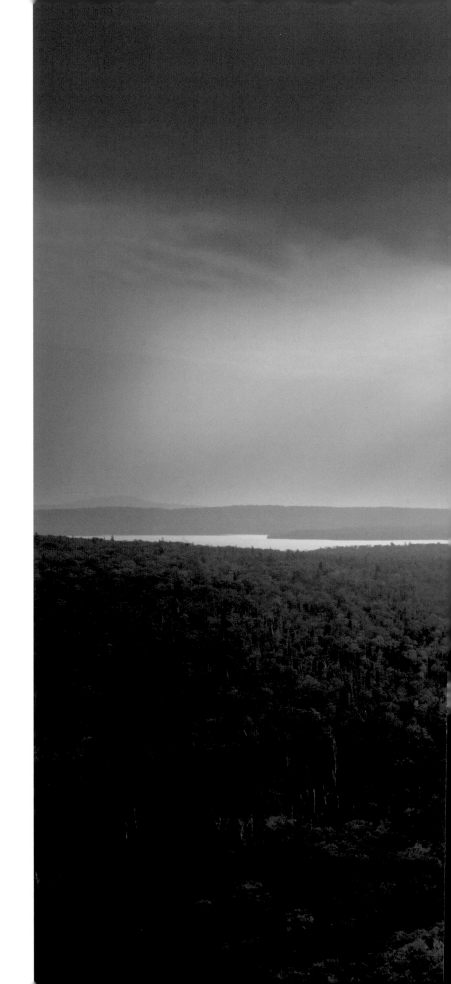

Thanks to The Nature Conservancy, majestic forests and breathtaking shorelines—magical places that have inspired novels and paintings and generations of hunting and fishing and hiking vacations—will still be a reality and not just a fond memory. ∽ Governor Jennifer Granholm

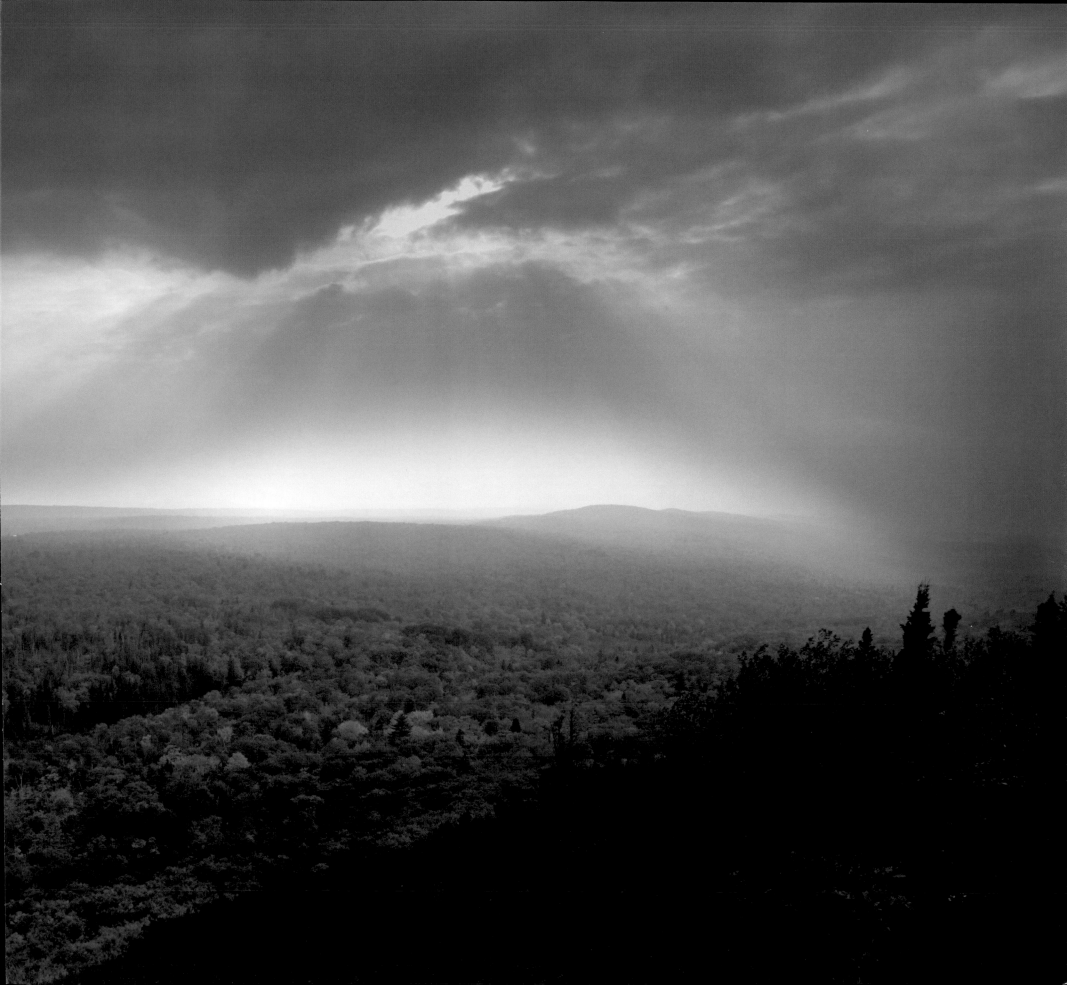

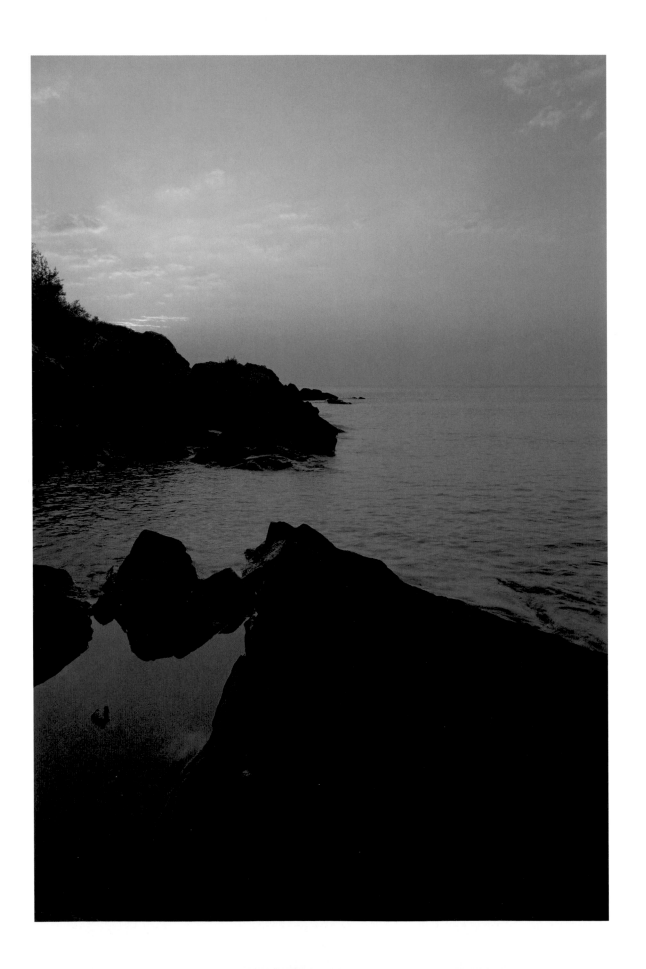

For those of us living in Michigan in the early twenty-first century, it can be hard to imagine what the first European settlers found here. If we look at the reactions of some of these, we can begin to get a sense of our own natural heritage. In 1702 the French explorer Cadillac described the land around the early settlement he established at Detroit as lush and beautiful, with rich meadows and wild fruit trees along the Detroit River. He went so far as to claim that it deserved to be called "the earthly paradise of North America." A little over a century later European American settlers pushed west into southern Michigan, drawn by the promise of an abundant, fertile land with oak openings "extending as far as the eye can reach, like lofty parks," as the *Emigrants' Guide to Michigan* put it. These oak savannas, as we now know them, appealed to the eye as well as the practicality of farmers looking for land that would be easy to clear. When Henry Rowe Schoolcraft canoed up the shore of Lake Huron and along the southern shore of Lake Superior with the 1820 expedition led by territorial governor Lewis Cass, he discovered a radically different Michigan, marveling at dense forests of pine and hemlock mixed with birch and poplar and, when he saw the carved bluffs of the Pictured Rocks, exclaiming over "some of the most sublime and commanding views in nature." As he

traveled up the Ontonagon River, he found rocky, tree-strewn banks and vast, unbroken forests—scenes of such wildness and solitude that he had difficulty imagining a human presence there.

In the process of settling the state and exploiting its natural resources since that time we have drained wetlands, dammed rivers, and cut all but a few remnants of our original forests. We have lost most of our prairies and savannas to development or tree growth no longer held in check by the periodic fires set by lightning and native tribes. Our forests are being fragmented, our lakes altered by human activity, and our shorelines claimed by development. Yet, despite the continuing transformation of Michigan's landscapes, we can find many reminders of our rich natural heritage: in our still extensive forests, our many rivers and inland lakes, and our more than 3,000 miles of varied Great Lakes shoreline. We are at a threshold at which we must decide what kind of Michigan we want for ourselves and those who follow us. If we want to protect the natural heritage that has given Michigan its identity and shaped its history, we will need to assume responsibility for nurturing this heritage and to commit ourselves to the kind of intelligent stewardship it will take to preserve it.

When we talk about the natural environment of Michigan, about what gives us a sense of place, we are likely to be thinking

JOHN KNOTT *Introduction*

about local geographies that have particular meaning for us: perhaps the springtime beech-maple woods of Sharon Hollow in Southeast Michigan or the Lake Michigan dunes of Point Betsie or the Two Hearted River and the area of pine and hemlock forest that it drains in the eastern Upper Peninsula. These are geographies of hope, to paraphrase Wallace Stegner, places that suggest what healthy, relatively undisturbed ecosystems can be. They offer opportunities for recreation, for discovery, for personal restoration when we need it, and they hold out the promise that our children and grandchildren will be able to enjoy similar pleasures in these and other remarkable places that embody what is so distinctive and appealing about the forests, the waters, and the shoreline of Michigan.

The fact that we are able to enjoy such places today depends on the work of The Nature Conservancy and of the various land conservancies, government agencies, and businesses with which it collaborates. Since its first project in Michigan in 1960, the Conservancy has expanded its vision to include whole ecosystems and watersheds; it has protected over 10,000 acres in the Keweenaw Peninsula and, through its Northern Great Lakes Forest Project, 270,000 acres of contiguous forestland in the eastern Upper Peninsula that links over 2,000,000 acres of forested landscape. Such ambitious efforts depend on an ability to form partnerships and work with local communities and diverse constituencies to protect landscapes that support local economies and cultures as well as wildlife and ecosystems. They require the support of scientists and practitioners who can identify and maintain biologically significant properties and of others who can articulate the mission of the Conservancy and represent it to the public. And on the generosity of numerous donors and hundreds of volunteers who contribute their time and labor on work days and assume stewardship responsibilities for Conservancy preserves.

The work of protecting ecosystems and watersheds proceeds in part by identifying places of unusual biodiversity that play important roles in these larger natural systems. One of these, 800 acres of prairie fen and intact floodplain forest bordering the River Raisin in Southeast Michigan, offers a dramatic illustration of the potential for restoring degraded

If Michigan is a state of mind, and not just one of fifty states, it's because it has a character shaped by its distinct geography. We are never far from its waters and woods—or when we are, we long for them. Even someone who doesn't go to the beach or the bank of a river, or walk in a forest, knows they are close. ∞ Hank Meijer

ecosystems with the help of volunteers. When the Conservancy began purchasing the land that makes up the preserve in 1987, only three acres of open fen remained in this critical piece of the River Raisin watershed. Now the restored fen is almost twenty times that size and still growing as the work of taking out farmers' old drain tiles, filling or damming ditches, and removing thickets of invasive and thirsty European buckthorn continues to restore the natural flow to the River Raisin from underground alkaline springs beneath the grasses and sedges of the fen. On one workday, a spring unexpectedly appeared in an area that had just been cleared of buckthorn. Native plants have returned from the seed bank, including rare edible valerian and Indian plantain along with more familiar wetland species. The Blanchard's cricket frog, the last population of another rare species in Southeast Michigan, is thriving. What began with a few acres has become part of a broader vision for conservation in the River Raisin watershed, a model from which other conservation organizations seeking to restore fen properties across the state are learning and a place where students come to do science projects.

The essays included in this book illustrate the range of ecosystems that The Nature Conservancy has protected and offer a series of compelling stories: about personal encounters with places and about some of the kinds of collaboration and innovative management practices the Conservancy employs to maintain and restore dynamic natural systems. Stephanie Mills evokes the geological past and recent history of Bete Grise, a rare Great Lakes coastal marsh on the Keweenaw

Peninsula protected from development through the collaboration of The Nature Conservancy with government agencies and local organizations, and gives us tantalizing glimpses of its wildness. Howard Meyerson's essay on the Coolbough Natural Area in Newaygo County tells a dramatic story of the use of fire to restore prairie and savanna habitat on property that the Conservancy has transferred to Brooks Township and continues to manage by agreement with the township. Anne-Marie Oomen, a farmer's daughter herself, shows how the Conservancy's efforts to preserve the quality of the Shiawassee River depend on novel ways of working with farmers to reduce runoff that threatens the health of the river. Janet Kauffman focuses on the incongruities of the "post-industrial restoration" at Erie Marsh Preserve, where marshes that serve as a critical link in a major migratory flyway depend on a complex system of dikes and pumps that mimic the action of the original marshes in sight of the traffic on interstate highway I–75. Kauffman tells a story of multiple recoveries that owe their success in part to another unusual collaboration, in this case between the Conservancy and a long-term leaseholder, the Erie Shooting and Fishing Club.

As many of the essays reveal, it takes active and scientifically informed stewardship to restore and maintain the health of the preserves, particularly to meet the challenge of invasive species. *Phragmites*—an aggressive, twelve-foot grass that crowds out the native vegetation on which waterfowl depend—constitutes the principal threat to the healthy functioning of the ecosystem at Erie Marsh Preserve. At Coolbough, Conservancy

field staff experiment with ways to protect newly restored lupine, the host plant for the endangered Karner blue butterfly, from overabundant white-tailed deer. Jerry Dennis tells a story of how the dunes of the Zetterberg Preserve at Point Betsie that he knew as a boy exploring Lake Michigan beaches with his family are under siege from invasive baby's breath, an escapee from the florists' trade that now threatens the endangered Pitcher's thistle and other native plants indigenous to the dunes. Here, as at other Conservancy preserves, fighting invasives depends crucially on volunteers, who find a sense of common purpose and personal satisfaction in working to protect the biological health of exceptional places.

Some of the essays that we include tell stories of personal discovery or renewal. Fly-fishing on the Two Hearted River in northern Michigan, where he can encounter a black bear lumbering across the highway, provides the tonic Jack Driscoll needs to rebound from a dehumanizing marathon of airplane travel. Keith Taylor finds in repeated visits to familiar woods at Sharon Hollow not only good birding but a welcome sense of solitude and even refuge, most memorably when he goes there with his family to try to recover from the shocks of 9/11. For Elizabeth Kostova, the pleasures of discovering Les Cheneaux and the northern Lake Huron shoreline are compounded by sharing them with her nine-year-old son Tony as they cruise the channels between the islands at sunset in an antique motorboat and the next morning are excited to find signs of wolf and moose in the shoreline meadow and woods of the Carl A. Gerstacker Preserve. Alison Swan discovers that introducing her seven-year-old daughter Sophie to the mysteries of a prairie and prairie fen being restored by The Nature Conservancy in the watershed of the Paw Paw River deepens her own sense of the complexities and promise of these places. With their curiosity and enthusiasm, Tony and Sophie suggest how children can renew our capacity for wonder and remind us of the value of preserving Michigan's natural heritage for future generations.

The essays describe only a few of the places that The Nature Conservancy is working to protect in Michigan. The photographs (by Michael D-L Jordan, Ron Leonetti, Richard Baumer, and others representing the best of Michigan nature photography) offer a more inclusive view of the range of the Conservancy's work and of the variety of landscapes that give Michigan a distinctive identity: its forests, prairies and savannas, wetlands, lakes and rivers, and immensely long Great Lakes shoreline. They reveal the stunning natural beauty and biological diversity of the kinds of places that the Conservancy continues to acquire and maintain, or transfer to others who will maintain them, for the people of Michigan. These places are valuable in themselves, as functioning natural systems whose ecological integrity can serve as benchmarks, but they are also valuable resources for a state seeking to make itself an attractive place to live and visit. Our natural heritage and what we do to preserve it have much to do with determining who we are.

The Nature Conservancy ultimately protects places for people. As Jerry Dennis concludes his essay, approving of finding footprints on the dunes at Point Betsie, we need wild places "where the wild exists side by side with the civilized," where "the boundaries blur." One of the accomplishments of The Nature Conservancy is to blur these boundaries and invite us to share and help care for the natural treasures of our state. ∞

Most of us struggle for success during our careers, but we also need to search for significance. I cannot imagine anything more significant—now and for my children and grandchildren—than to work with The Nature Conservancy to help preserve the wonders of Michigan's natural world. The sound of a loon's call; the flash of a brook trout; the whisper of the wind through the pines; the plash of Lake Superior waves on the beach. They mark our lives and nourish our spirits. ∾ Philip H. Power

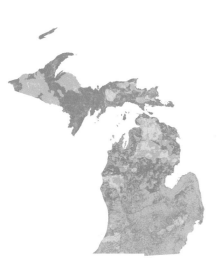

Michigan's land cover
includes approximately
19,300,000 acres of forest-
land. Nature Conservancy
priorities are shown in
light green.

Michigan's unique geography, climate, and soils create the conditions necessary for an unusually rich mix of forest types. Our temperate forests—the fifth-largest forest acreage in the United States at 19.3 million acres—are part of what is known as a "transition zone," with the broad-leaved forests commonly found in the southern United States coexisting and interspersed with the needle-leaved boreal forests commonly found in northern Canada and a wide variety of forest types in between.

Southern Michigan's once extensive prairie lands now sputter through an archipelago of protected areas on the western side of our state, with roads and subdivisions cutting through where fields of lupine once grew. The prairie has indeed become "the rarest of Michigan ecosystems," as the essay on the Paw Paw expresses it.

It is the places where forests and woodlands come together with prairies or water, however, that provide the real backbone for protecting the diversity of life on earth. For example, the vernal pools found on the Conservancy's Nan Weston Preserve at Sharon Hollow—low-lying areas in the forest that are wet only in the spring—provide critical breeding habitat for amphibians such as the tiny spring peepers, which fill the air with their mating songs only at this time of the year. The surrounding remnant upland forest is where the peepers and other amphibians spend most of their lives, under the leaf litter and logs and underground, making the juxtaposition of the two habitats crucial for the survival of these tiny creatures and others like them.

To stem the tide of development and save remaining prairies and forestlands for future generations, The Nature Conservancy and its partners are working to apply fire and a full array of management tools at Coolbough, Paw Paw prairies, the Nan Weston Preserve, and a host of protected sites across Michigan.

*Land*

As a lifelong Michiganian, I feel strongly that we should never take for granted our unique natural assets that enrich our quality of life. Some of my most peaceful and memorable moments have been spent enjoying our glorious northern Michigan lakeshore. I am delighted that this book is being published to share some of the great places in Michigan with those who may never have seen them in real life, but I am even more pleased that this publication will help protect and preserve additional Michigan natural treasures. ∞ Richard Manoogian

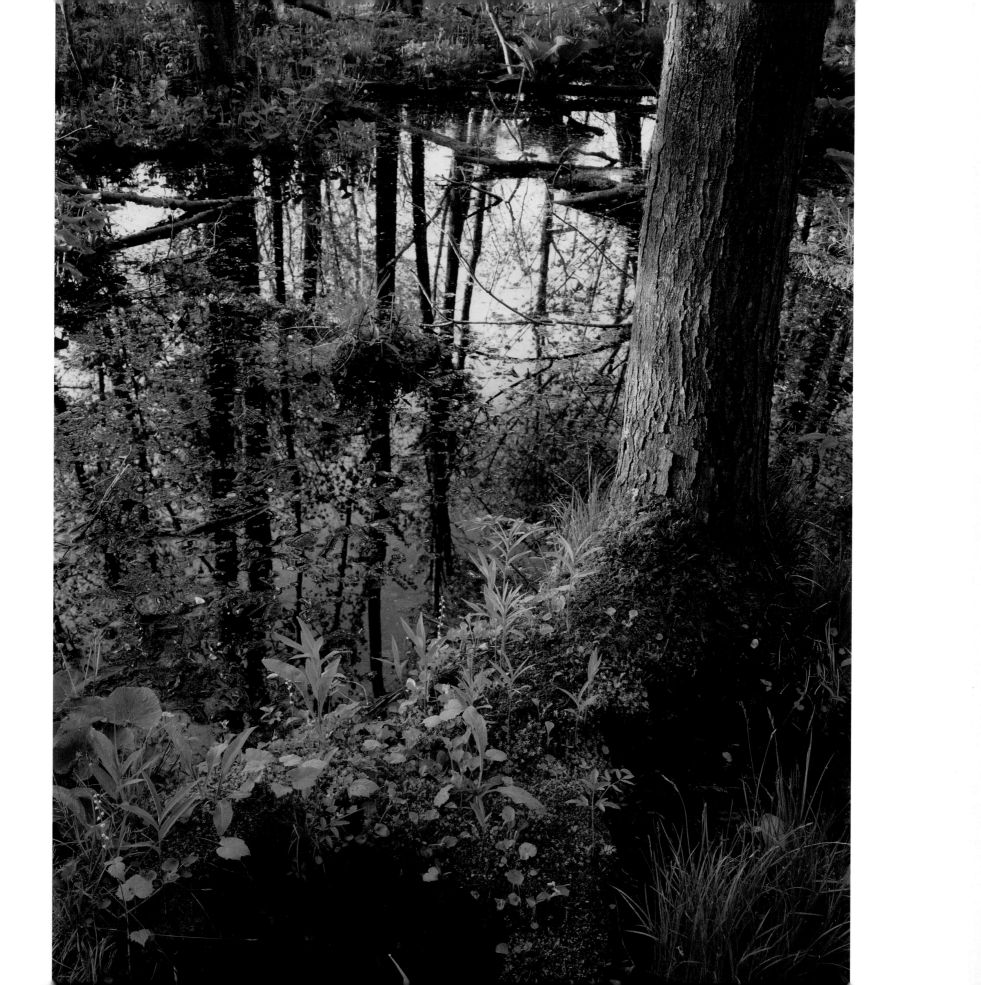

I pull off to the side of a dirt road in southwestern Washtenaw County beside what looks to be yet another southern Michigan woodlot, a second-growth forest covering what had once temporarily been fields and pastures. But here there is the Nature Conservancy sign: "Saving the Last Great Places on Earth." I'm always slightly amused to see the sign here, in southeastern Michigan, an easy hour's drive from Detroit and less than half that from my home in Ann Arbor. Aren't "great places" supposed to have mountains or oceans, grand vistas and large mammals? Here, from the side of the road, looking into the Nan Weston Preserve, an uninformed cynic might see just another mosquito-infested midwestern rural tangle.

I know, however, that there is more hidden down the trail that begins behind the sign. I've been coming out here since the Conservancy first acquired part of this land in the early 1980s, although I'm not sure I come for the reasons the organization intends. The mission of the Nature Conservancy is very clearly "to preserve the plants, animals and natural communities that represent the diversity of life on Earth by protecting the lands and waters they need to survive." The measure of the organization's success is the level of diversity it is able to preserve. I know that crews of volunteers have worked out here pulling the invasive black locust from part

of the sanctuary; they are probably working now eliminating garlic mustard and are keeping their eyes open for other nonnative species that might crowd out the plants that have thrived in these forests and swamps for millennia. I know that more people have worked thousands of man-hours in mud and clouds of bugs through many summers to maintain the small trail through the woods and the boardwalk that cuts through the swamp. Although I have occasionally volunteered for other crews in other places, I've never worked here. I come to the Nan Weston Preserve for selfish reasons, when I need to get away, when I need comfort. For refuge. Escape. I come for solitude. And I come to be replenished.

We certainly respond to some natural environments because of the emotional and intellectual baggage we carry with us, but I am also fairly certain that some places—and perhaps more places than most people might imagine—have geological and biological attributes that combine to affect and inform us in unexpected ways, in ways that we might define as spiritual. Even the layout of the Nan Weston Preserve lends itself to that response.

Just look at the map. First we go down a path for a few hundred yards through a narrow area of second-growth trees—oak and hickory with some beech and maple and several large, straight, black cherry trees—until we get to

KEITH TAYLOR *The Nan Weston Preserve at Sharon Hollow*

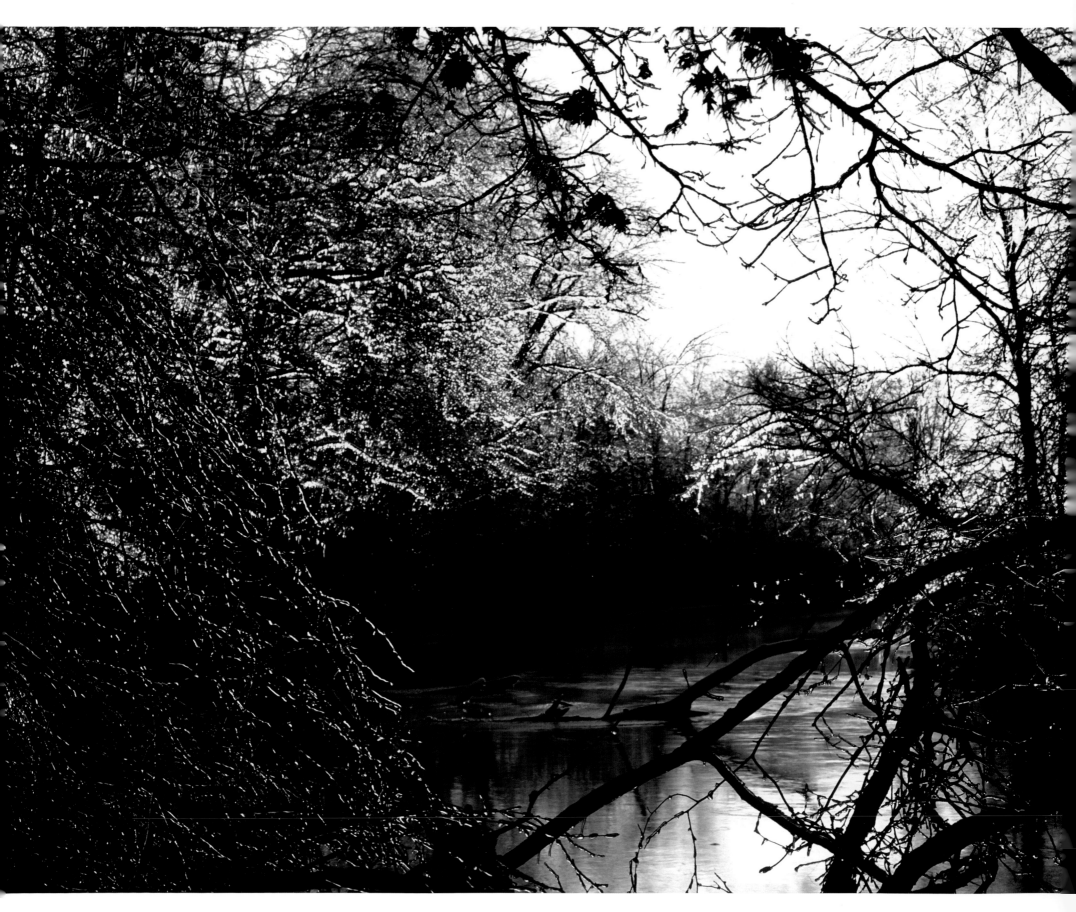

a large, cleared swath below a power line. Suddenly the sight lines open up in straight, artificial rows, but there is a profusion of wildflowers that grow here, and the sounds of the birdcalls are often very different than in the swamp or the forest. After the power line, we go down a small incline to the swamp. Here a recently placed stone marker—which shouldn't be confused with a naturally occurring glacial erratic—defines the beginning of the boardwalk through the swamp. On the stone is a bronze plaque that says, "This Boardwalk is dedicated to the Memory of Nancy Elizabeth Hand." For those of us who have been visiting this place for a while, this boardwalk is a tremendous gift provided by the people who did the work, people we will likely never meet and who will have only a vague sense of the value of what they have given us. Not only do we walk easily through a place that was often impenetrable in the early days, but we do so without leaving deep holes in the mud or crushed ferns. After the swamp we rise up to a beech and maple forest that descends gradually for a half mile or so to the River Raisin.

That's a simple enough description. Yet it captures nothing of the sense of discovery that accompanies this walk, no matter how many times I make it. The swamp comes as a surprise, and the boardwalk moves through it in a leisurely way. It is made by the waters that flow below it in this area formed between the lobes of the last retreating glacier. The water is forced up under pressure, and there are places where it actually flows up and out of the tops of the metal pipes that frame the boardwalk. And the swamp is interestingly *not* all flat and low but filled with small rises, even things that look like muddy ridgelines. I can actually stand here and look up to see the ubiquitous marshy skunk cabbage growing above me. And, of course, despite all the work to preserve this place, there are signs of the things even The Nature Conservancy can't protect us from. Four species of ash grow in the Nan Weston Preserve, including the beautiful square-twigged blue ash, and there are a few dead and dying ash trees in the marsh. The imported emerald ash borer has made it here, too. We can't escape all the consequences of our actions, even here in this refuge.

**Michigan is the greatest state in the union. Four terrific seasons, rivers, streams, wildlife, beautiful lakes, great vistas, and nice friendly people. It deserves every penny we spend to preserve it for generations to come.** ∾ Bill Parfet

But there are still the compensations of a protected place. I come out here mostly in spring and fall and always see good birds. Almost every year, before the trees leaf out, I can get a glimpse of migrating scarlet tanagers, the males so ostentatiously bright and unmistakable on the tops of trees. Migrating and nesting warblers come to feed on the bugs that rise from the waters of the swamp. I've seen the delicately blue-hued cerulean warblers migrating through here, and parula warblers in the nesting season. Louisiana waterthrushes are often very active in the swamp or other smaller marshy areas by the lower trails. Wood thrushes sing their beautiful melodic songs from secretive perches hidden behind leaves from April through September. Pileated woodpeckers call from the forest down by the river all year long. I have an acquaintance in Chelsea who comes out here often enough to keep a bird list of the species he has seen at the Nan Weston Preserve, and his list is moving toward 150 species now. Laura, an acquaintance particularly obsessed with ferns who is willing to brave the worst of the mosquitoes, even in midsummer when I allow myself to be kept away by the bugs, sent me a list of nineteen species of fern she found here one day in July. These include ones I know, such as bracken, cinnamon fern, and the delicate,

seemingly fragile maidenhair fern. But her list has others I don't recognize, ones with evocative names I'll have to look up, such as the narrow-leaved glade fern.

In the woods just after the swamp, the beeches rise up like cathedral columns—much bigger than the elephant legs guidebooks compare them to—and those trees shade the understory enough to keep it open and expansive. The forest, too, has its own wildness and in particular its floor of spring ephemeral wildflowers. Squirrel corn and the wonderfully named Dutchman's-breeches grow here, as well as a carpet of trillium so thick that the flowers seem to stretch forever in early spring. I come looking for them in April. They feel like a gift, one I haven't earned and might not deserve.

Farther down the trees get smaller as the trail enters the riparian forest, the important buffer zone that helps protect the watershed and a place that has its own inhabitants, including a rare colony of the federally endangered Indiana bat. But when the trail finally reaches the river we find the water moving slowly, already affected by the dam, unseen downstream at Sharon Hollow. The river, the quiet heart of the Preserve and the goal at the end of the trail, brings us back to history. The mill behind the dam was converted by

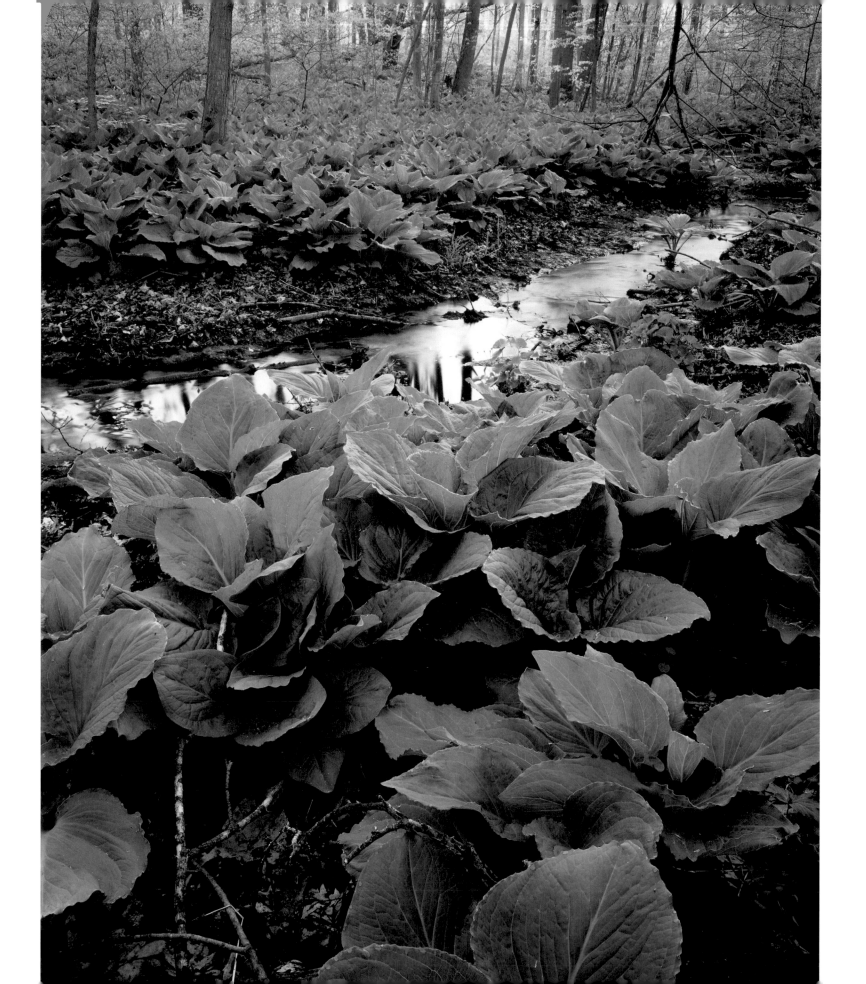

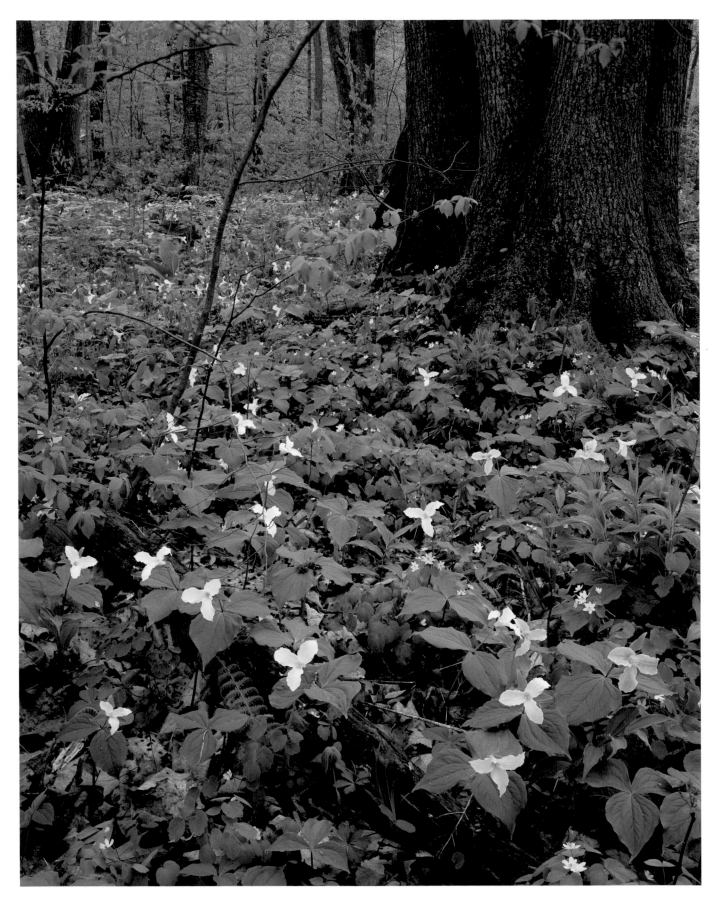

Henry Ford into one of his early small parts plants. Here a few people made cigar lighters for the early Fords. But the River Raisin—still carrying the French syntax that once designated it the River of Grapes—flows past all that, past the modern villages and under the freeways of southeastern Michigan, to Lake Erie. One of the great and defining battles of American history was fought where this river empties into the big lake, in January 1813, and the echoes of that battle, too, are part of what floats up this quiet river. After the attacks on September 11, 2001, after the days of watching news reports and reexperiencing that particular horror, my family and I came out here and sat for hours by this river, quietly talking and napping, recovering some sense of ourselves and our environment. But we also remembered that earlier battle downstream, and realized that a refuge is necessary but is not really an escape from our lives as citizens.

Alone in a different year, after I've turned back at evening and am walking toward my car, I stop at the little bridge at the beginning of the boardwalk. In the beech trees above me, what seem to be hundreds of grackles, gathered in a flock for the fall migration, are picking apart beechnuts. The furry outer shells and the triangular seeds inside them are falling around me like a hard rain. Out of the corner of my eye, I see the dark shape of a small hawk—too quick to actually name, although I think it may be a Cooper's hawk—fly below the grackles, and they suddenly explode upward in a flurry of fear. The sound of this rush of wings is enough to make me jump, and it takes several minutes for my heart to resume its regular beat. Still, when I turn to leave I am left with that memory of a quick sound rising from the top of the forest, and I find it somehow reassuring. ∾

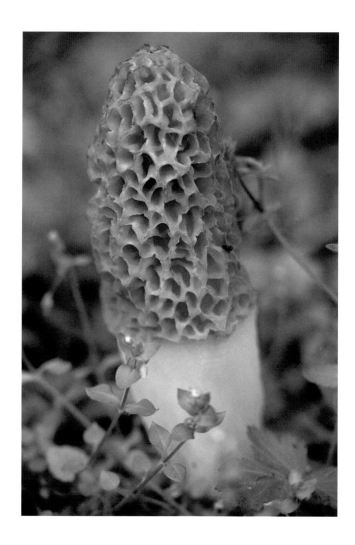

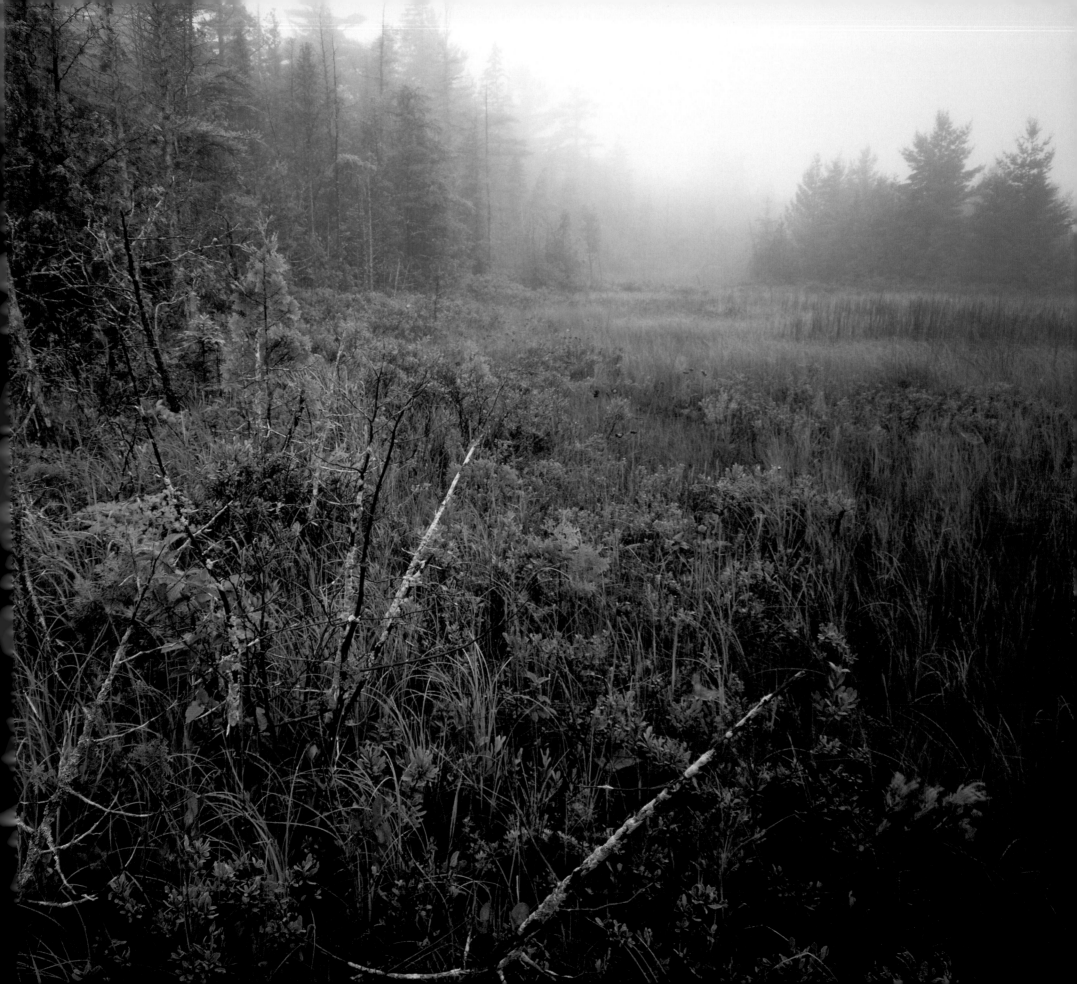

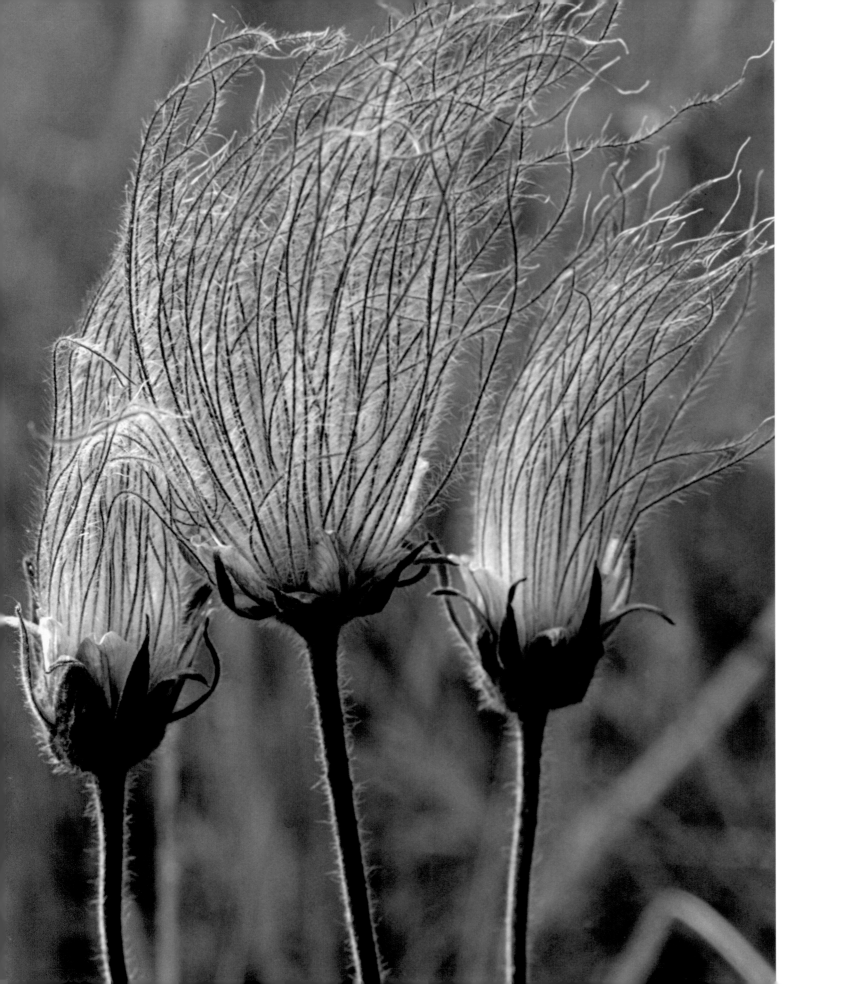

The mist hangs over the landscape like a balm. It is all that is left of a replenishing rain. The woods are quiet except for the sound of my footfalls, the occasional song of a robin, and the incessant buzz of a deerfly that has come to get acquainted. A bead of sweat runs down my face. It is mid-July, warm and muggy. I mop it from my forehead and continue down the trail at the Coolbough Natural Area. It is not my first trip here, but it is my first alone.

The 400-acre Newaygo County parcel is owned by Brooks Township and managed by The Nature Conservancy, a combined effort to preserve a large natural landscape in a rapidly developing county. It is one of two such Conservancy projects in the area—both endeavors to restore pine-oak savannas in a terrain that has grown up full of trees, the result of a "twentieth-century" stricture against letting forest fires burn.

Coolbough offers an experience in landscape transformation. Lush green summer hues have replaced drab spring colors. Dried leaf litter hides under the thickening grasses. A sea of dark ferns obscures the barren ground. Brightly colored mushrooms punctuate the earthen trail. Everywhere I look I see signs of fire. Not the wild flash blazes of a lightning strike or the ravages of a drought-fueled wildfire but the charred remains of well-mannered burns, the prescribed fires that are the tool of a modern-day land manager.

The trail is easy to follow. More than four miles of it meander through the natural area with its wetlands, creeks and bogs, its open prairies and wooded uplands. I've set off along the Prairie Loop, a 1.3 mile walk through a more recently burned landscape. Conservancy managers say it will someday resemble what existed before European settlers arrived in western Michigan. It was an era when natural fires took their course, scouring the landscape, making way for the new.

What we know about the presettlement landscape is a matter of record. Historians, scientists, and others refer to written descriptions penned by early settlers who spoke of open savannas. They were common. It was the later decisions to put out the wildfires, to keep settlements from burning and valuable timber from going up in smoke, that started the slow, steady progression that eventually filled fields with trees.

I pause to swat a pesky fly, undoubtedly as the earliest settlers here once must have. The sun has now burned off the haze. It is hot again. A wide-open field full of grasses draws my attention. It is surrounded by trees, the forest that once filled it. A few standing trees remain in its center. Their trunks are blackened by fire.

There is something compelling about the space, something fresh. I am inexplicably drawn into it. I want to walk in the opening. My reaction was similar the first time I saw it. Just three months before I had toured the property with a

HOWARD MEYERSON *Coolbough:*
*An Experience in Land Transformation*

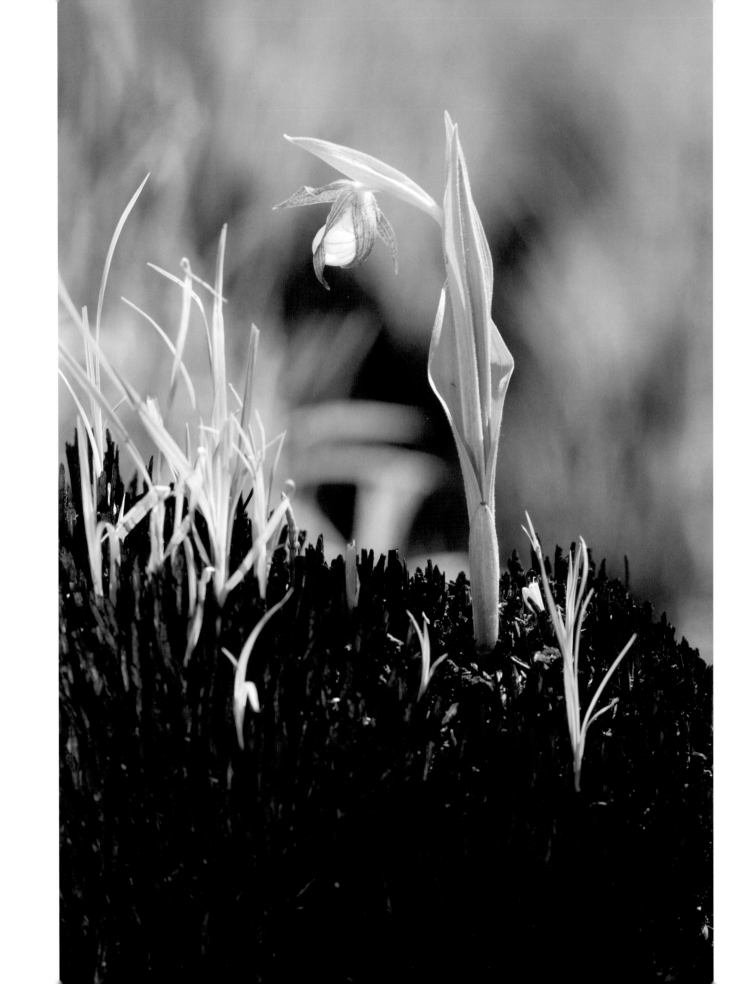

Conservancy biologist and "the fire boss." His job is to set and control the fires that are used to burn the duff and other detritus that cover the seeds of native grasses and other precious plants that lie dormant in the soil, giving them a chance once again to thrive.

This field is one of the prairie restorations Coolbough is known for, one of its many special habitats. It is an area of stark contrasts. Interspersed throughout its flourishing grasses are the charred remains of the trees and bushes that once grew here. The field has been burned twice in recent years. Those are the times that the fire boss and as many as ten others let the drip-torch do its work, setting the backfires that would creep against the wind to burn off the undergrowth in a designated area. Today the blackened branches and scorched tree trunks are a powerful backdrop for the smaller, more delicate, special plants that now grow here, rare species such as the prairie smoke with its feather-duster-like strands, a state threatened flower from the rose family.

The idea of burning the land, destroying what stands to create something better, may seem counterintuitive. But the role of fire is deeply rooted in the natural world. Wildfires have long shaped the natural terrain whether caused by lightning or by Native American cultures that looked to clear the land for a variety of purposes. Fire is so integral a natural force that certain plants cannot reproduce without it. Jack pine seeds find their way into the ground only after the searing temperatures of a fire crack open the cone. Any of the species that grow in the sunlit oak habitat here will require fire now and then to keep from eventually being shaded out of existence.

This prairie has been transformed by fire, which stripped its languishing layers of duff. That, in turn, allowed sunlight to penetrate the soil. The burned branches also nourish the soil, decomposing over time and providing essential nutrients. The charred trees that remain have become vulnerable to insects and disease. They, too, will contribute by a slow, steady process of deterioration. The opening is full of thick

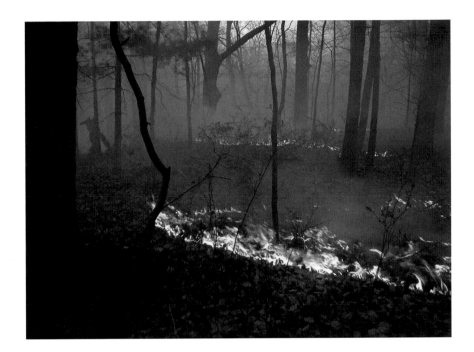

grasses such as big and little bluestem, savanna grasses that thrive following fires. They are tall, green, and healthy. They hint at the promise of restoration.

~~~

Prairies are not simply western phenomena—places where grasslands sway pushed by timeless breezes, where cattle graze complacently and the men who tend them know one rattler from another. Here in Brooks Township prairies were once common. Large openings, running from 600 to 1,500 acres, were not unusual. That is no longer the case. Contemporary surveys of the landscape here show that only a patchwork of remnant prairies and oak-pine barrens remains. They run from 1 to 80 acres in size and add up to one-eighth of what existed in the 1830s.

Farther down the trail, there are birds singing in the trees. A light breeze rustles through leaves up high. Much to my regret another deerfly has come to visit. That makes two.

As a lifelong environmentalist, and a member of The Nature Conservancy for many years, I believe it is vital that we all do our part to protect our planet. Because of the abundance of lakes, rivers, woods, and shoreline that surrounds us, those of us fortunate enough to live in Michigan have a special duty to preserve our natural heritage. It is a gift we must give not only to ourselves but also to the entire world and all the generations to come. ∾ William Clay Ford Jr.

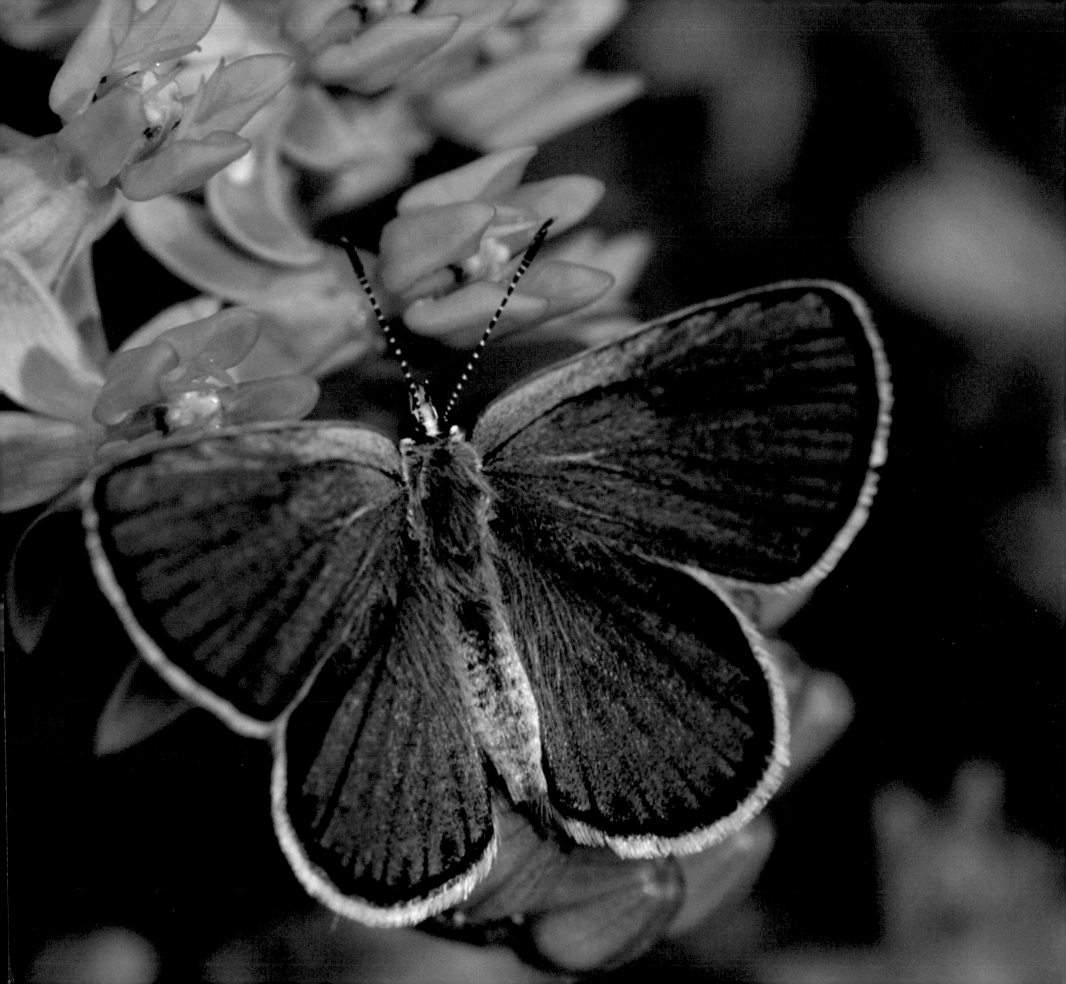

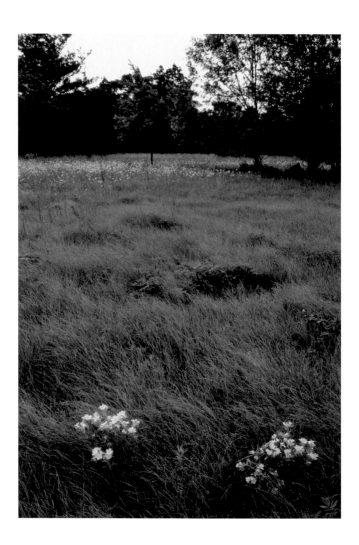

My eyes are drawn to a simple blue flower—actually a clump of them. They are lupine plants: an uncommon flower that is essential to the survival of the federally endangered Karner blue butterfly. Lupine is the butterfly's only food. Without it, no butterfly. It's just that simple. Scientists have long recognized that lupine is its only hope for survival. But the rub is that lupine only grows in the sandy soils of the oak-pine savanna.

The Nature Conservancy's strategy here is to create the necessary prairie and savanna habitat and encourage lupine growth and propagation. Lupine seeds are collected each year from plants that grow at Coolbough and other nearby properties whose owners allow Conservancy staff to collect the seeds. They are planted on other parts of the property. The butterfly, with its delicate blue wings and its penchant for rare plants, can be found here but not yet in abundance.

That isn't the case for whitetail deer and wild turkey. Both are plentiful. There are tracks and signs of deer along the trail. Both benefit from the change in the landscape, which provides them with more food to eat than the forest that once grew here. Ironically, that includes the lupine.

It was the fire boss who told me, with more than a touch of exasperation on that warm spring day, that the flowers "are like candy for the deer." Whitetails had nipped off every one last year. Any the deer don't take the wild turkeys do. Not the flowers per se but the seeds, the very foundation of lupine-filled savannas.

Creating fields where lupine flourish is a challenge under the best of circumstances. These conditions call for extraordinary measures, which explains the wire-mesh enclosures I see ahead that are built over small clusters of lupine plants. The enclosures are, in fact, "exclosures" designed to keep the deer from browsing on the plants. The lupine underneath are less robust than when I saw them in the spring. None seems to have escaped. There is likely to be a new design next year.

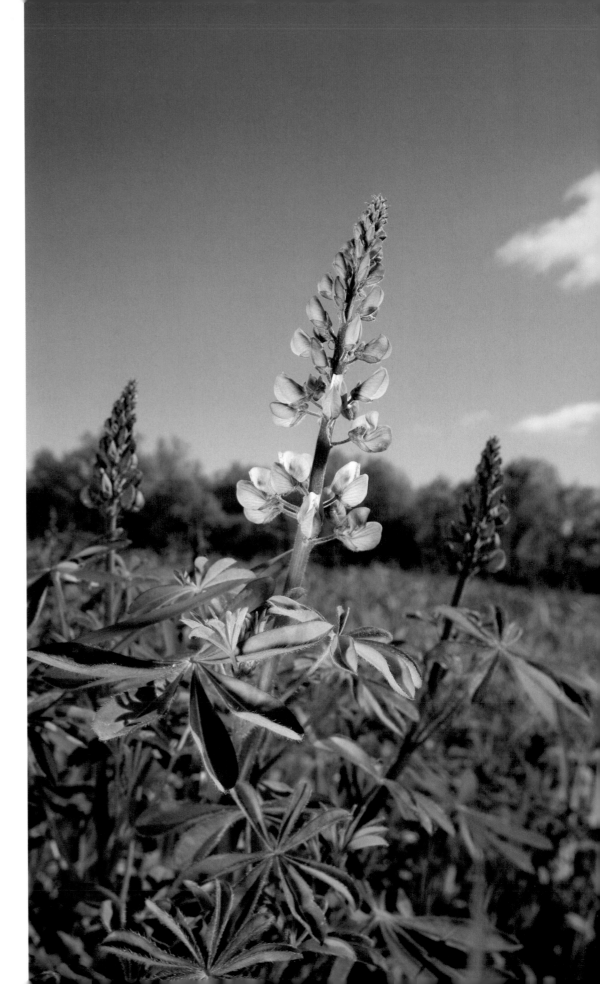

As the trail winds back through the property, I snake off the prairie trail and on to another. I am heading to the other side of the property, to an area where entire fields of Scotch pine were once grown as Christmas trees for market. Their now dried-out trunks lie stacked at the back of the field where they were dragged after being uprooted by a giant machine from the rows where they had grown for years.

This open field is barren. It is a work in progress that holds considerable promise. Native plants are beginning to show on the uprooted landscape. The pines needed to go to restore ecological integrity. They were a Johnny-come-lately that never made good. Christmas trees, that is. They were scrubby and overgrown. Whole stands had simply been abandoned. They became a home for beetles, which damaged the white pines that grow nearby. But the more compelling reason was the promise of a renewed prairie. By supplementing what remains in the seedbed with seeds brought from other areas, it may be possible to bring back the lupine and prairie smoke, even the Karner blue butterflies. Lose the trees and the field might blossom wildly.

This Scotch pine field is vast and empty, but having seen the other field I need only a little imagination to see the future grasses swaying. I suspect I will never see cattle grazing here, but I guess, taking yet another swat at a buzzing target, that the people who tend the plants and grasses here can tell the difference between various biting flies. ∾

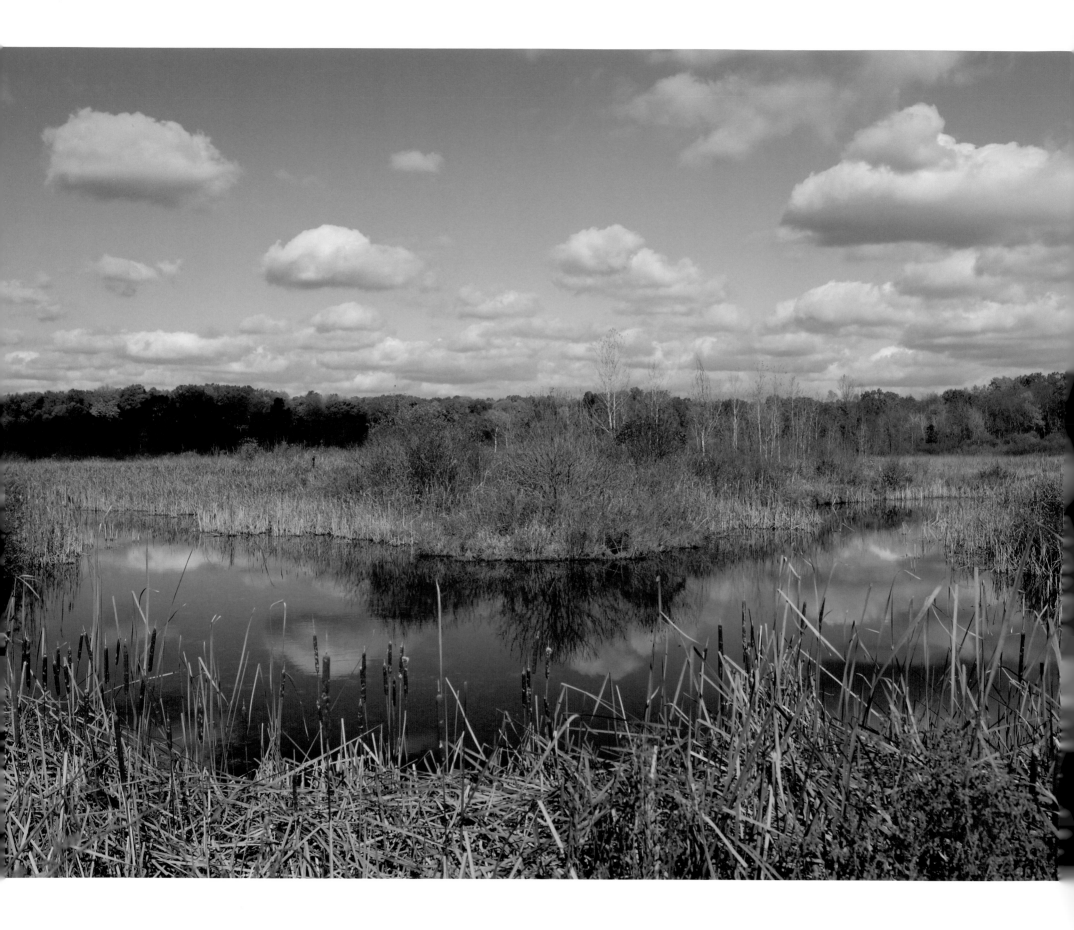

outhwestern Michigan's Paw Paw River begins in the Paw Paw Lake, south of Kalamazoo, then follows a winding westerly route through fields and woods, farms, towns, and, increasingly, subdivisions till it empties into the St. Joseph River near Lake Michigan. Driveways, lawns, and highways are decidedly inhospitable to the longtime locals (box turtles, sandhill cranes, and lady's slippers, to name just three), but an extraordinary diversity of wildlife persists. The Nature Conservancy has taken on the task of ensuring it endures.

I've already received an invaluable orientation from Matt and John, two Conservancy biologists, when I bring my family to the Lawton Prairie, near the East Branch of the Paw Paw. A small sign implores "Please . . . No Collecting." I've come to collect impressions. My daughter Sophie and husband David have come along to meet a Michigan prairie, Sophie's first. We plan to leave with nothing more than notes and photos.

We spread out, each one of us stepping quietly through the tall grasses and wildflowers, our senses tuned in a way we've rehearsed on dozens of similar hikes together. It's mid-morning, late August. The sky is milky gray, relieved by the glowing bruise of sun that's almost too dim to cast shadows. The air smells green: grassy, weedy, and truly clean. The humidity is so high our sweat doesn't evaporate. Sophie, at

seven, is the best naturalist among us. She keeps her gaze close and notes details her father and I miss: a brightly colored beetle, a swarm of caterpillars. Beneath her boots, roots probe as deeply as twenty feet. Far off we hear automobile traffic, and then an Amtrak train roars by on the steep embankment that gives this tallgrass prairie its northern border.

Railroad right-of-ways all over the United States have served as conservatories of prairie species. Now that the prairie has become the rarest of Michigan ecosystems, these right-of-ways are invaluable. The Nature Conservancy has been nurturing this one for ten years. A major tool is fire, though evidence of this is so subtle it would be easy to miss. Sophie stoops to point out a deer track in dirt left bare when last year's plant litter was burned away in the spring. Scattered around us are sassafras seedlings, offspring of the fencerow that bounds the prairie to the south, but none of the saplings that would persist without fire. There is nothing inherently bad about sassafras trees, of course, but we've grown so deft at plowing under and paving over prairies, and at suppressing the wildfires that reinvigorate them, that we've left ourselves with no option but to preserve and restore. This means discouraging the growth of trees in places like the Lawton Prairie.

After the train has roared past, insect song lies heavy in our ears again: cicadas, crickets, and other clicks and buzzes

ALISON SWAN *Along the Paw Paw*

I can't identify. Scattered bird peeps and chirps remind me to look for migrating birds. It's the kind of quiet one finds in nature, neither silence nor din, layered to complexity beyond anything human made.

The Nature Conservancy has counted 180 different species here. Today this tangle whispers "autumn." There are plenty of colors: greens, of course, and scatters of golds, purples, and whites. None of these have faded, exactly, but they've mellowed. For plants it's the season of final flowering then ripening, for animals the season of laying in and laying on: food- and fat-gathering time. Seeds drop from the elegant stalks of big bluestem we jostle as we pass. We count dozens of large butterflies: orange monarchs; yellow swallowtails, one with iridescent sky-blue "eyes" on its wings; another that's bright orange and brown; another that's black and blue. They cling to the blossoms of thistles, blazing stars, and goldenrod. There are yellow jackets everywhere, utterly uninterested in our nectarless selves.

I show Sophie and Dave the spiky seed heads of the rattlesnake master, a prairie native I've learned from Matt and John. "It's said that American Indians made poultices from the roots to treat snakebites"—a reminder of one of the reasons why the preservation of biological diversity is in our own best interest. Many medicines do come from plants.

Sophie begins picking seeds from her denim overalls. "I don't want to bring back seeds." She is a quick study. But seeds cling to our bootlaces, our clothes, even the hair on our arms, and so we have unfortunately collected a tiny emblem of the larger challenge: we humans sculpt the landscapes we inhabit, even for a stretch of time as brief as half a morning, and so we had better be mindful about how we do it.

~~~

Our next stop, just a few miles up the road near the Paw Paw's headwaters, provides examples of sculpting that remakes and sculpting that restores.

I lead Sophie and Dave along a two track to an open field where bulldozers recently scraped away everything alive, including the topsoil, in preparation for putting up a tract of houses. We stop to drag our hands through a shallow puddle. Two frogs leap from the murky waters: a green and a leopard. There are deer tracks everywhere.

The Nature Conservancy, the brand new owner of these acres, is going to regrow a prairie from scratch. I point out little orange flags that mark the hundreds of plugs of Indian grass planted by a local high school's conservation club. The Conservancy has also seeded big and little bluestem grass. The disbelief on Dave's and Sophie's faces—no doubt they're picturing the Lawton Prairie—reminds me of my own reaction when Matt and John laid out the long-term management plan: burns, herbicides, and even weeding by hand. Once mature, this prairie will help preserve the flow of groundwater to the relatively pristine prairie fen next door, flow that surely would have been disrupted by houses and roads. A long history of fire suppression has already altered the prairie fen but not irrevocably. It is still rich in prairie species.

"Let's go see the prairie fen," I say.

Sophie says good-bye to the toad she's been playing with. You have to love a girl who gamely tucks her jeans into knee-high rubber boots and heads off into eastern massasauga rattlesnake territory. We are in no real danger from these rare, shy snakes unless we reach into a hole in the ground or inside a hollow log. I lead the way, and the trail's so soggy and faint that I'm glad I've been here before. We step on a board across an especially soggy spot where we can see that the water flows north toward the East Branch of the Paw Paw. Soon the willows give way to grasses and prairie flowers, some of the same ones we saw at Lawton Prairie.

Prairie fens, among the rarest ecosystems in the Great Lakes, are unique to places like southern Michigan where thousands of years ago retreating glaciers dumped piles of rock debris, now covered in soil and vegetation. That porous ground draws water to the surface, producing a wet, fecund place that filters water that will eventually feed Lake Michigan. The Nature Conservancy has reintroduced controlled burns, and they seem to be winning their battles against what Sophie calls "takeover plants" such as the glossy buckthorn.

Dave lifts Sophie up so she can see. Again, the greens are

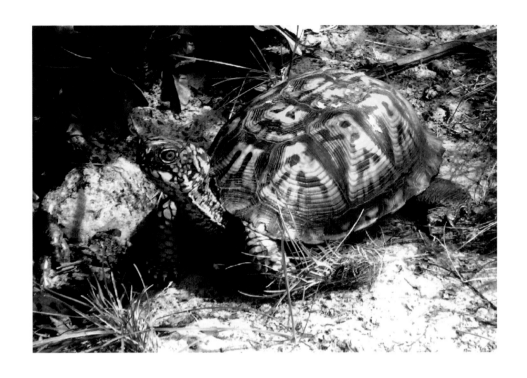

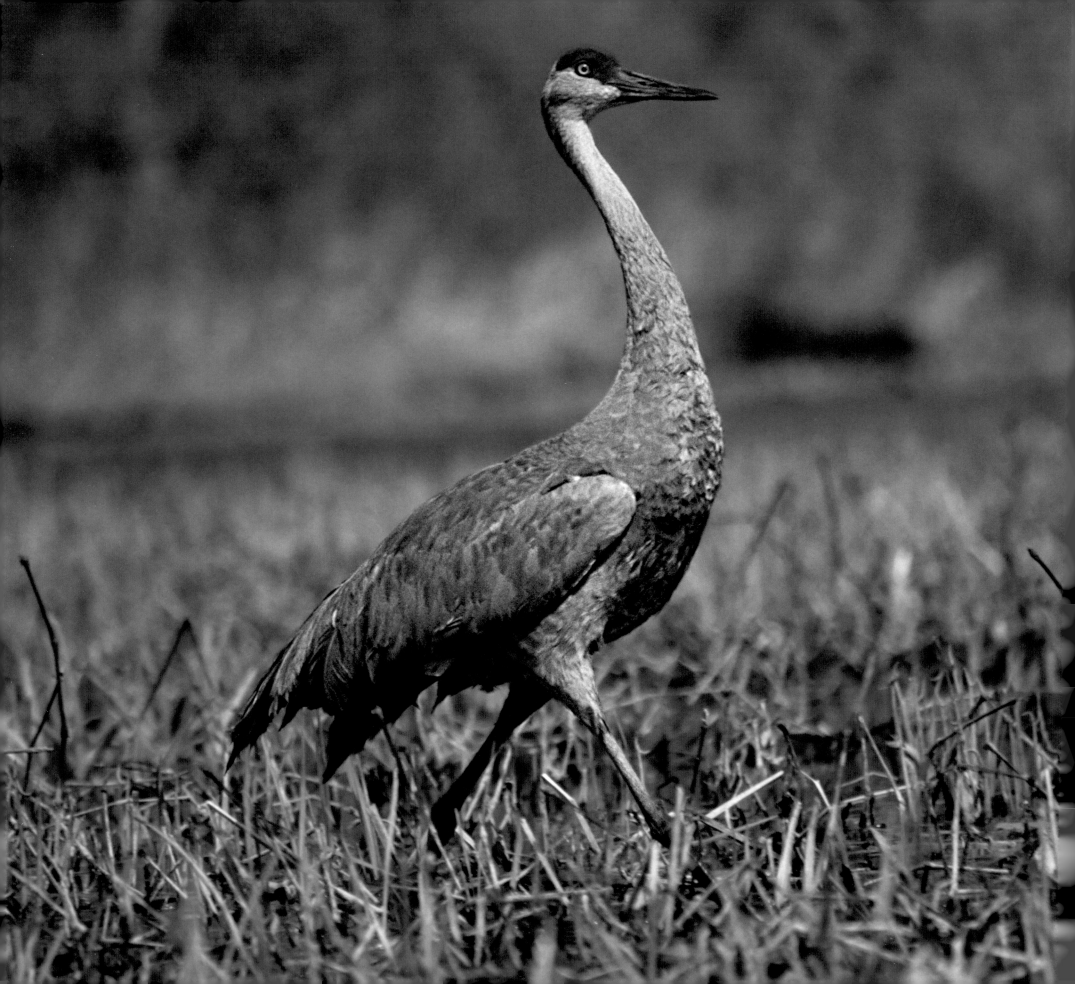

myriad, flecked with the purples of lobelia, ironweed, blazing star, the golds of sunflowers, cinquefoil, goldenrod, the white of Indian plantain. In short order we see a goldfinch, a hummingbird, more monarchs and swallowtails, damselflies and dragonflies. Matt has told me sundew and pitcher plants, carnivorous plants that have so fascinated us elsewhere, thrive here, too.

It's a place where it's easy to feel how little we human beings really know about the natural systems that make the earth inhabitable, how much mystery still remains. I decide in that moment to return in the spring to see how much progress the upland prairie has made. I'll wade out into the prairie fen, too, to find the colony of white lady's slippers, a rare orchid, that Matt said bloomed after the last spring burn. It's the only kind of lady's slipper I've never seen. The pitcher plants will be in bloom. If we're lucky, sandhill cranes, those huge, sand-colored, wading birds, will be passing through. Something to look forward to.

~~~

We're all hot, tired, dirty, and happy when we pull into Gary and Julie's driveway just a few miles downstream from the prairie fen. Sophie and Dave are eager to see the box turtles I've told them about. In Michigan, every baby box turtle is practically a miracle, and here there are scores. Gary and Julie bought this house some twenty years ago. Almost immediately it became clear that they'd landed in something of a box turtle

sanctuary, and they set about managing their acres accordingly. I'm happy to find Gary at his back door pulling on his boots.

In their backyard we get our first good look at the Paw Paw itself, a clear-running brook, really, still shallow and narrow so near the headwaters. Sunlight filtered through the treetops dapples the muddy bottom and sparkles the surface.

Sophie charges ahead with Julie, who's showing her things. Meanwhile, Gary points out the differences between the two sides of the trail. Box turtles need water (the river), cover (the woods), and especially open sandy places if they are not only to survive but reproduce. Gary and Julie have been cultivating openings, mostly through the selective girdling of undesirable trees, for years. Recently, they've joined forces with The Nature Conservancy, which reintroduced fire here in 2004. The right side of the trail was burned, and the evidence, as at the Lawton Prairie, is subtle: more grass, more mayapples, more hepatica—all evidence of a looser forest canopy admitting more light.

Julie and Sophie are pulling up sassafras seedlings. Julie shows Sophie that the roots smell like root beer, a favorite of Sophie's, and she collects a handful to take home and simmer. With no prompting, Sophie notes the acrid smell of old fire and spots the colony of American Colombos. Huge and prehistoric-looking, like oversized garden lilies with sprays of flower bracts emanating from the single thick stem, Colombos produce stems, leaves, and flowers anew each year, reaching heights of up to 8 feet in a growing season that lasts only a few

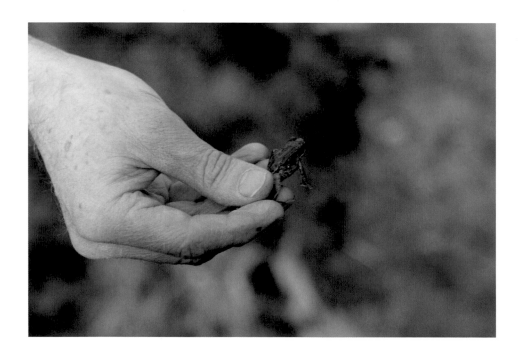

months. In Michigan, they're uncommon. Here there are hundreds.

We head off the trail and into a sandy opening. Almost immediately, we spot a box turtle foraging. He begins to retract his head, then seems to think better of it and instead trains his orange eyes on the five of us. His species has been roaming our planet, essentially unchanged, for 250 to 300 million years, and I wonder what he sees.

Sophie squats down to look closer. She doesn't seem to need to touch. The shell, about eight inches long and three inches high, is beautiful, a pattern of yellowish-green flecks and dots on brownish green. Another turtle I saw here with Matt and John bore an oranger pattern that seemed to have been stroked onto the brown shell with a paint brush. Gary tells us that after the age of four or five, each box turtle's shell pattern is unique, like a fingerprint.

"Where does he go during the fire?" Sophie asks.

"We light the fires so early in the spring that he is still underground sleeping. And think about where the heat from a fire goes. It goes up. He probably doesn't even feel it."

A few weeks later I hear Sophie tell her grandpa about our day near the Paw Paw. She makes no mention of the heat, the scratchy prairie grass, or the long drive. The turtles are what she remembers most. I like to imagine her leading her children into a new sandy clearing to meet a box turtle. Individuals have been known to live as long as 130 years; Sophie's children might meet the very same turtle she did as a child. ∾

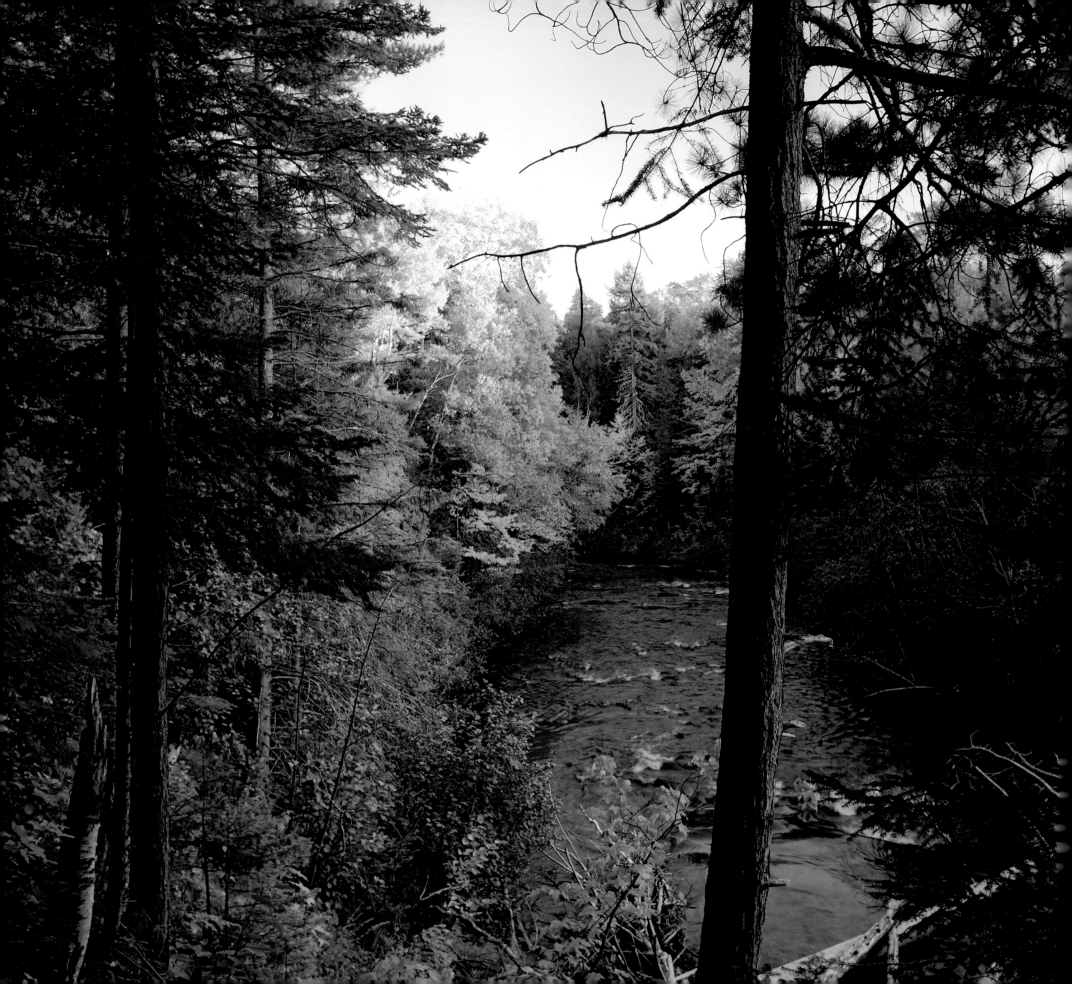

I have always believed the Great Lakes are deep in the psyche of everyone who has lived in Michigan. I can remember as a young child climbing up to the top of Sleeping Bear Dunes and seeing a beautiful blue ocean. What makes Michigan unique is not just the water—it is our shoreline, our dunes, our harbors, our rivers, and forests. Our people sometimes take it for granted. Preservation for future generations has to be the watchword.

∞ Governor James Blanchard

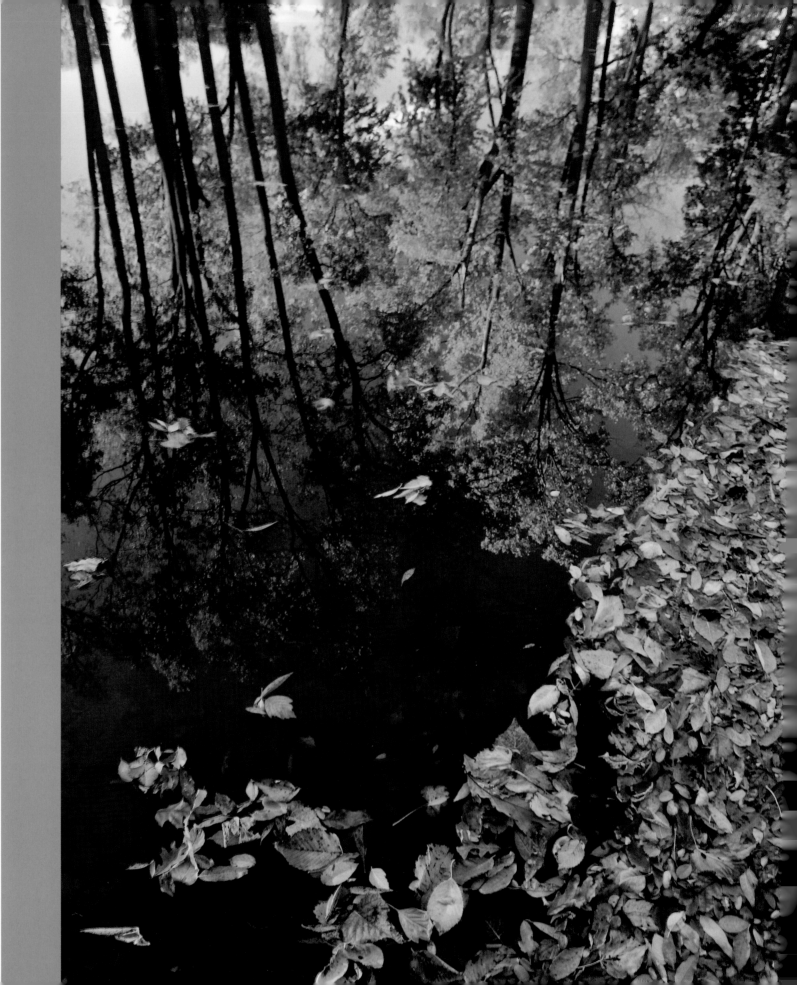

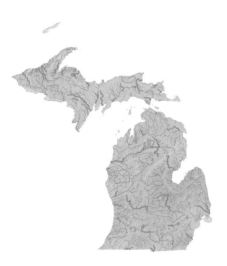

Michigan features over
51,000 miles of rivers
and streams and nearly
890,000 acres of inland
lakes. Light blue areas
indicate The Nature
Conservancy's aquatic
system priorities.

Michigan's abundance of rivers and lakes has shaped our collective identity, our culture, and our heritage. These water resources—51,000 miles of river and more than 11,000 inland lakes—have provided generations with the means to live, work, and play. While the Two Hearted River was immortalized by Hemingway, Southeast Michigan's Shiawassee River has inspired the toil of generations of farmers and their love for the land. Each day the water affects our lives and the world around us.

Our waterways provide spawning habitats for fish and migration corridors for songbirds and waterfowl. Our lakes, rivers, and streams provide high-quality drinking water, abundant supplies of water for agriculture and other industries, and statewide access to water-based recreation.

The Nature Conservancy is focusing on a balanced use of these water systems to ensure their long-term health and integrity and the sustenance we need to survive. Human use has severely strained our rivers and streams with the construction of dams, the impacts of incompatible land use practices, and the draining of our wetlands. Today altered natural water flow patterns are one of the most severe threats to aquatic biodiversity in our state. In partnership with farmers, land-owners, and local, state, and federal conservation groups, and through land protection efforts and the education of water managers across the state, we can, and must, find effective solutions.

Water

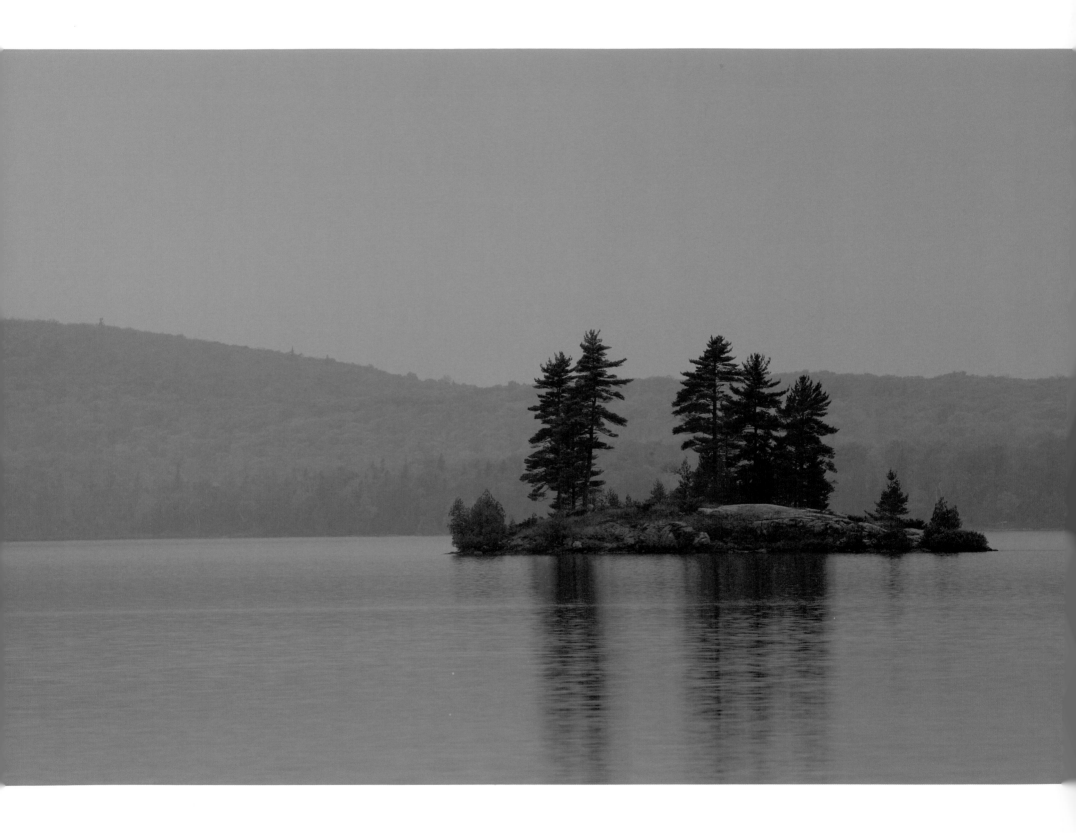

The tranquility and beauty of the inland lakes are what I love. It is one of the ways we can really find peace. It helps us put into perspective how short a time we are here. They were here long before I came, and I hope they will be long after I am gone. We have to be sure they thrive and are protected. ∽ Rick Snyder

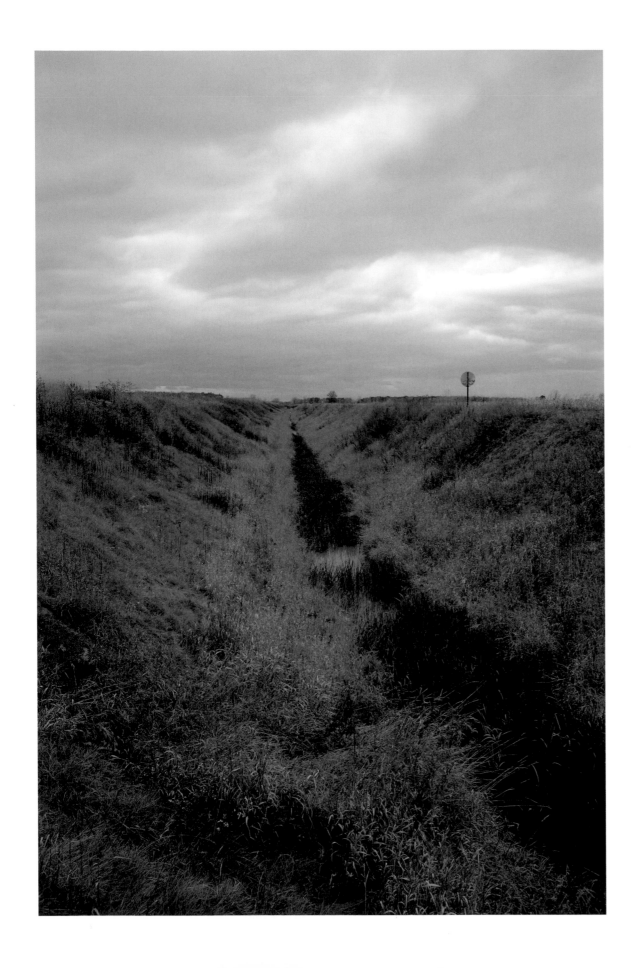

I wanted to write something pretty about the Shiawassee River, something to honor its old and slow beauty, its moody, coffee-colored waters. I wanted it to be about the moist air hovering over its surface, about rich weed beds drifting in their slow dance. But today I am not about the river but about dirt and ditches. Hundreds of miles of ditches. The ditches of the Shiawassee River are both shallow as bowls and so deep it would be dangerous to fall into them. Most are as straight as the grid of fields they serve here in Shiawassee County, but a few of the oldest curve here and there like small streams, having been cut long ago to follow the original low creases in this land flattened by glacial seas. Their surface is marred by the signature riffle of authentic tributaries. Some ditches have small sections of intact ecosystems, complete with fish. Some wildlife uses them, though the effects of sediment and contaminants are still being studied. Most are thick bottomed with the kind of muck that could hurt you. As I look down this V-shaped crevasse, a county drain that feeds the river, I can see the snouts of field tile thrust out like underground animals, a few feet below the surface, over the steep grade of the ditch. Most are still flowing with the last rain, splashing into the dark water that shifts slowly toward the Shiawassee.

Is there such a thing as a healthy ditch?

The Nature Conservancy thinks so and is promoting a new kind of two-tiered ditch that will slow the runoff and allow absorption. Still, before the ditch, there is the field, as much a part of the watershed as the ditches. It starts there.

I am a farmer's daughter. I grew up on a farm here in Michigan, and, though my life took me away from the fields, I am still and forever of the fields. Little on this earth satisfies me like standing in a big field, looking out over the acres, assessing, as all farmers do, from what comes through the senses as much as what comes through science and experience. From the buffer zone, that narrow bridge of land that can make the difference between healthy rivers and contaminated, I inhale white alfalfa and the odor of earth drying, that edge of acridity. I pick up some soil and squeeze it. When I open my hand, I can tell by feel that the clay content is high; the soil is good but of such fine-grained quality that when compressed it becomes dense. I look over these long acres. There is a beauty in the order of a field, but there should be a touch of wildness, too. These fields are a little too tidy for me, without a break in the visual texture. Sometimes a perfectly weed-free field indicates an overuse of herbicides. A few weeds here and there may indicate a farmer striving for balance between herbicide application and weed control. I run my eyes over the range, looking at color and height.

ANNE-MARIE OOMEN *Ditches and Rivers*

This field's color is a little irregular, indicating where the drainage through recent rains has left some seedlings in oversaturated soil, soil that cannot absorb the water. Of course, it's a tiled field, and within reason it should be able to take in and absorb the rain. That the field cannot, or cannot as effectively as it should, is one of the reasons the river is in trouble, so flushed with sediment that fish populations are threatened, not to mention the other forms of wildlife that depend on a river.

I turn from the field to Craig, my Nature Conservancy guide to the ditches. I can tell by the way he looks over the fields that he also loves these sprawling acres. Earlier in the day he was able to show me a map of the Shiawassee watershed. Shaped like our hemisphere, the two continents of the watershed include hundreds of square miles. I was stunned as he pointed out feeder creeks in blue, ditches in red. In some areas the ditches matched the creeks in distance, adding miles to the rivers. I know most of them will be shaped in that traditional V, not the tiers that could hold high and low waters. It may seem obvious, but they feed the rivers as much as any tributary.

We walk carefully over a railroad that divides a barley from a soybean field. We cut down into a low grade and through a wide buffer into one of the old ditches where the water sampler is located.

"Look," Craig says, pointing toward bottom. Here the water runs clearer in soft riffles. "It actually braids down there a ways. Just like a creek." He nods approvingly. The barrel-shaped water sampler perches a few feet up from the bottom of the ditch. Its long probe is set in the current of the ditch. With a teacher's care for clarity, he tells me how the probe in the ditch bottom is triggered by flow to pump water into containers at regular intervals over the duration of a "rain event," measuring both intensity and duration. He removes the circular cover. Inside, twenty-four one-liter containers nestle in a daisy shape. All are full.

He shows me sediment caked on the bottom of each. In the early part of the rain, that layer is thin. As we examine each liter, the sediment at the bottom thickens to equal a solid inch or so. As the rain ceased, the liters clear again. Together they are the story of runoff.

"This was a heavy rain," he says.

No wonder the standing water. No wonder the tiles, under compressed soil, could not absorb the water quickly enough. No wonder the river is threatened by the direct runoff caused by such events.

We are connected. Rivers, fields, ditches.

We climb back into his pickup and drive away from this ditch, but I notice that every road is bordered by ditches, surface arteries fed by the tiling systems that drain these wide fields. I look to the horizon. There is no place like the flatlands to see the sky. Because the land is a pronounced horizontal line, the sky springs up from it, high and close simultaneously in this humidity, making the blue softer

The one thing that is a constant in Michigan is the beauty of the state. Michigan is a lifestyle. What a great place to live, raise families, and enjoy the outdoors! These are challenging times, and as we look to the future, we must preserve and protect Michigan's beauty because our natural resources represent who we are as a state. ∞ Roger Penske

and thicker. In the Shiawassee's late afternoon that sky is omnipresent, darkening now to the west, a front line just as straight as a gray sheet drifts toward us. Storm rising.

Craig glances sideways at me. "Let me show you the machine," he says.

~~~

Like most farmers, I love good equipment. It's old school, I know, but I care about machines that make feeding people easier. Tractors are high on my list of most admired contraptions—though I always prefer the smaller ones to today's monsters. Still, I love the architecture of farm machines. I love the engineering and the mechanics of farm equipment and tools—so perfectly practical but still exotic in their utility. I love standing in the machine yard among disks and plows and combines and implements so weird looking I cannot name them. There is mystery and power in farm machines. But the downside to big machines is that their interaction with soil is imperfect. Below the topsoil, dirt compresses under the great tires and weight of this fine steel, and between the topsoil and the tiling hardpan forms. Hardpan is a poetic word. It is what it says—hard pan, a pan of such depth and heft that it can hold an entire rainstorm intact on top of an untiled field and damage crops and river in the form of rampant runoff. That is why rainwater does not drain effectively into the soil, why runoff might flow directly to the ditches instead of being filtered through the soil, why the ditches are fuller than they should be with sediment, why a field might not be the right green, and standing water becomes a suffocating foil over the drowned seedlings or, worse, inundates the Shiawassee.

The subsoiler is a new machine for me. The Zone Commander is what Craig proudly calls it as we pull into Reed's Dairy Farm where it is parked. In an innovative plan, The Nature Conservancy owns the machine but rents it out to farmers who would rarely purchase such an expensive machine for limited use. I approach it as I would a restless animal. It sprawls like a red insect, ten feet across and almost as long. What I want to see are the legs, the downward thrusting tines that do the work of breaking hardpan. The legs are set to a

depth just below the hardpan. Pulled by a tractor growling at a mere three miles per hour, it shatters hardpan, allowing underground conduits for rain.

This "contraption" could help the river.

I can see the way it works, its design sense. Coulters and shanks coordinate to keep surface disturbance at a minimum while piercing the layer beneath. I run my hands down the tine. There is something so muscular that it pleases me. This machine does what it is supposed to do, and the farmer in me breathes that sigh of awe and contentment. If farmers will use it—and The Nature Conservancy is making that possible—this is a machine that will work.

We drive to the river. The sky is dark, the front closer. This looks like a hard storm to me; a rush of warning wind gusts my face. From a little-used bridge, we study the weed beds. Craig tells me about the fish, varieties of waterfowl, the way farmers are gradually becoming more receptive to the best management practices—no till, wider buffer zones, breaking the hardpan. Still, I remember what one man told me. "Because of the runoff, the floods that used to rise and fall over three days rise in twelve hours and sustain. The river can't take that; the river won't hold it all."

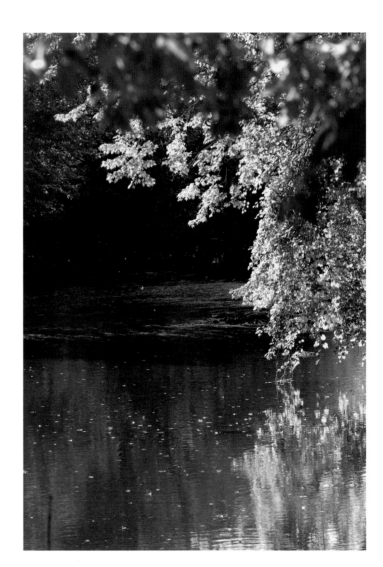

I think of the two-tiered ditch system, the one designed in levels to hold both low-water and high-water flows, the ones designed to slow the flow of even heavy rains. A ditch like a sponge. Ditches that would mimic, in miniature, a wide old river. I wonder again, could there be a ditch, in combination with other practices, that would hold and hold and hold?

Could the ditches be so good that they could save the river?

I look at the weed beds, home to underwater life. The long strands ride the warm, slow current. The water is clear enough here to see that the habitat would be pure fish pleasure. This is what I had hoped to write about—but before we can celebrate the river, we must understand the connection to everything else, including ditches.

Low thunder rumbles, and we look up to see the wind rising. The first dimples of rain pock the river's surface. A spike of lightning pierces the momentous sky. The ditches will darken with rain, as the river will darken with what they sweep into it. ∞

Our economic history—whether of agriculture, or timber, or manufacturing, or tourism—is tied to Michigan's natural resources. If we respect our heritage, we should respect our environment. We should be doing a lot more than we do to protect these resources.  ∞ David Frey

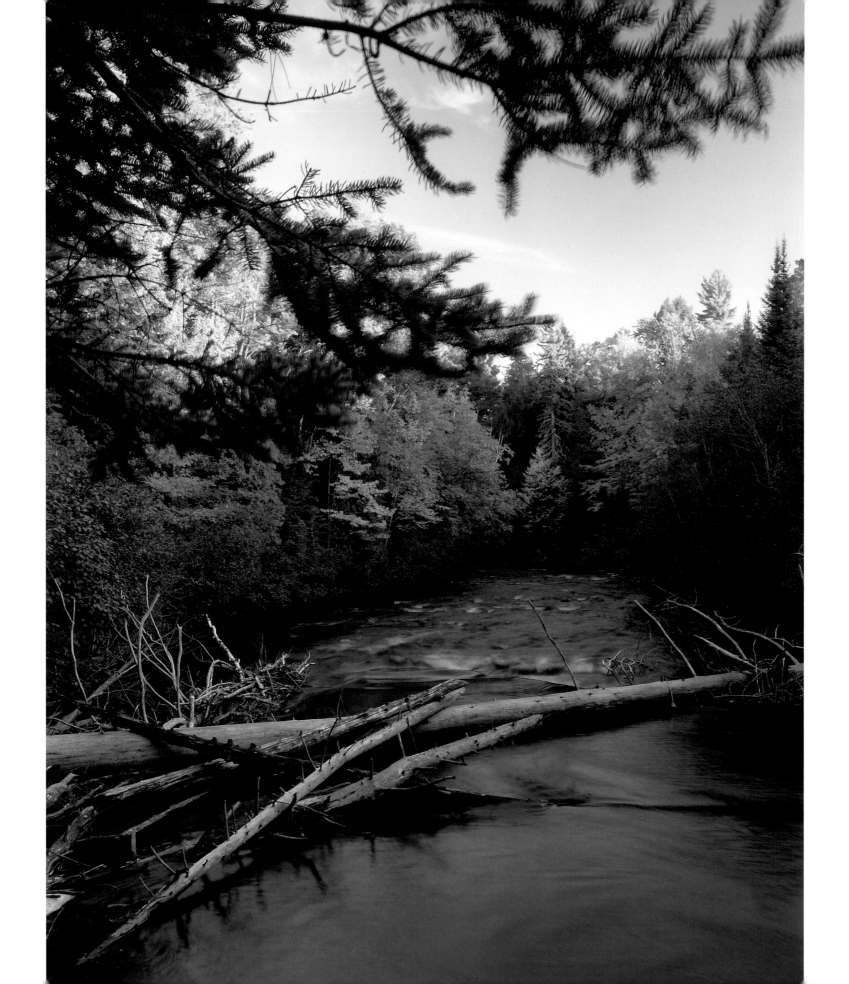

The plane touched down in Traverse City, nearly on time for once, and the pilot announced over the intercom, after we'd taxied to a complete stop, that we should—I quote here—"All rise," and I sat there instead, afraid of opening my eyes and finding myself either in church or in court.

Overextended by book-tour and writing-conference traveling, I was ready for reentry, ready to be back in northern Michigan for awhile.

"Think of the consummate folly of anticipating to go away from here," Thoreau says in an 1858 journal entry. Advice not lost on me, by which I mean I needed some time on the river, and the Two Hearted seemed just within driving distance of first light.

My wife Lois is the maestro of tones, at least when it comes to reading mine over the cell phone, and the chances that she'd have my fly rod and vest and our waders already in the Subaru Outback were good and without me even asking. What she hears in my voice at such moments is that post-stress plummet into malaise and boredom that can leave you angry or dazed for days, sometimes longer. Sometimes, if you're not careful, for a lifetime without a soul.

Saint Thomas Aquinas: "Trust the authority of your senses," and even in my jet-lagged delirium mine never fail to tell me that casting to a surface-feeding rainbow or brown or brookie is preferable to shelling out big dollars for some shrink to prime the soul-dredge out of my exhausted psyche.

My concentration late at night has always tended inward, particularly if I'm in full retreat north, searching yet again for something tangible and worthwhile enough to worship and embrace. And right there, at the junction of the roads to Trout Lake and Paradise, the first black bear I'd seen in over a year lumbered across Route 28, immense in the tunnel of the headlights, its obsidian eyes staring back as if to remind us that the old-rag gods of ego and despair occupy no permanent place in the tundra. Or shouldn't if we're alert and sufficiently amenable to those fabulous enchantments of otherness.

No traffic either, and so I stopped the car and thought, "This is what humankind must have survived by—this primitive beauty—and the inexhaustible spirit to save and protect what's left of its disappearing." The good news is that The Nature Conservancy has protected more than 271,000 acres in the Upper Peninsula (UP). A healthy chunk of it is located around the Two Hearted, a landscape by and large absent of topography, meaning no spectacular panoramas, but I'll take the subtle shadings of open bogs and beaver dams and town names such as Laughing Whitefish any day over the more salable and traveled destinations to which these uncreaturely times subscribe. Vegas comes to mind—this twenty-first-century's city of Cibola—but I'd rather work on Maggie's Farm, though

JACK DRISCOLL   *In the Heart of the Two Hearted*

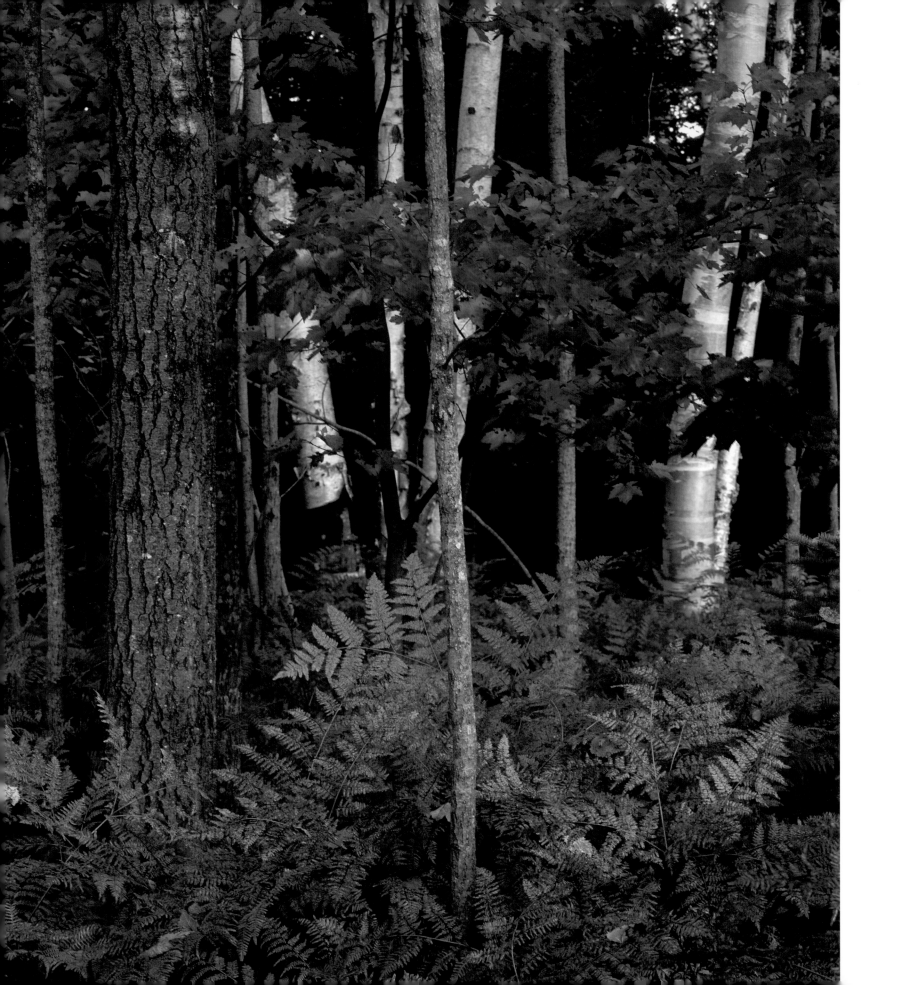

that's just another low-grade clamor of mine, and Lois, riding shotgun, had already turned the volume down on Dylan anyway and taken my hand in hers. Almost no moon but in the incandescence of our imaginations we had no trouble seeing the thick, brambly underbelly of tag alder that the black bear left shaking in his wake.

We were shaking a little, too, in all the right ways, the Outback in neutral, and, with the windows down, that ancient, pungent animal musk was almost close enough to lick, or even kiss, and maybe we did. What I know for certain is that you do not come magically alive like this on an airplane, that dead, recirculated air as dry as brick dust in your lungs. Or in a Barnes and Noble where, if you're lucky, half a dozen listeners might assemble to see if you can hold their interest with your stories, more and more of them set in the UP.

Here's a true one: an early breakfast at a local diner in Newberry—toast and eggs and bacon—and a white-haired woman in the booth behind us explaining to the waitress that, "Even in a conversation with God I do most of the talking." And prattle on she did, nonstop and occasionally to that imaginary nobody sitting across from her. As a fiction writer I turn only reluctantly away from human oddities, and on another late July day I might have lingered longer, pen in hand. But Lois and I had driven half the night in pursuit of a natural shrine or two that might quiet and still us for awhile. They exist even in industrial forests if something of their essence has been reclaimed by groups such as The Nature Conservancy and Trout Unlimited. I'll put a knee down anywhere in praise

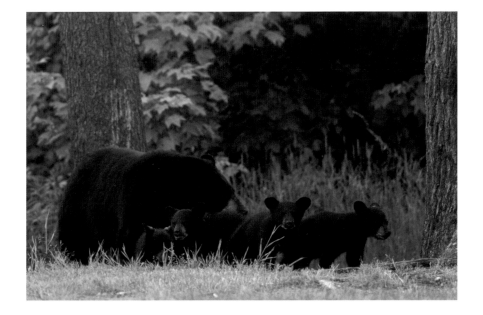

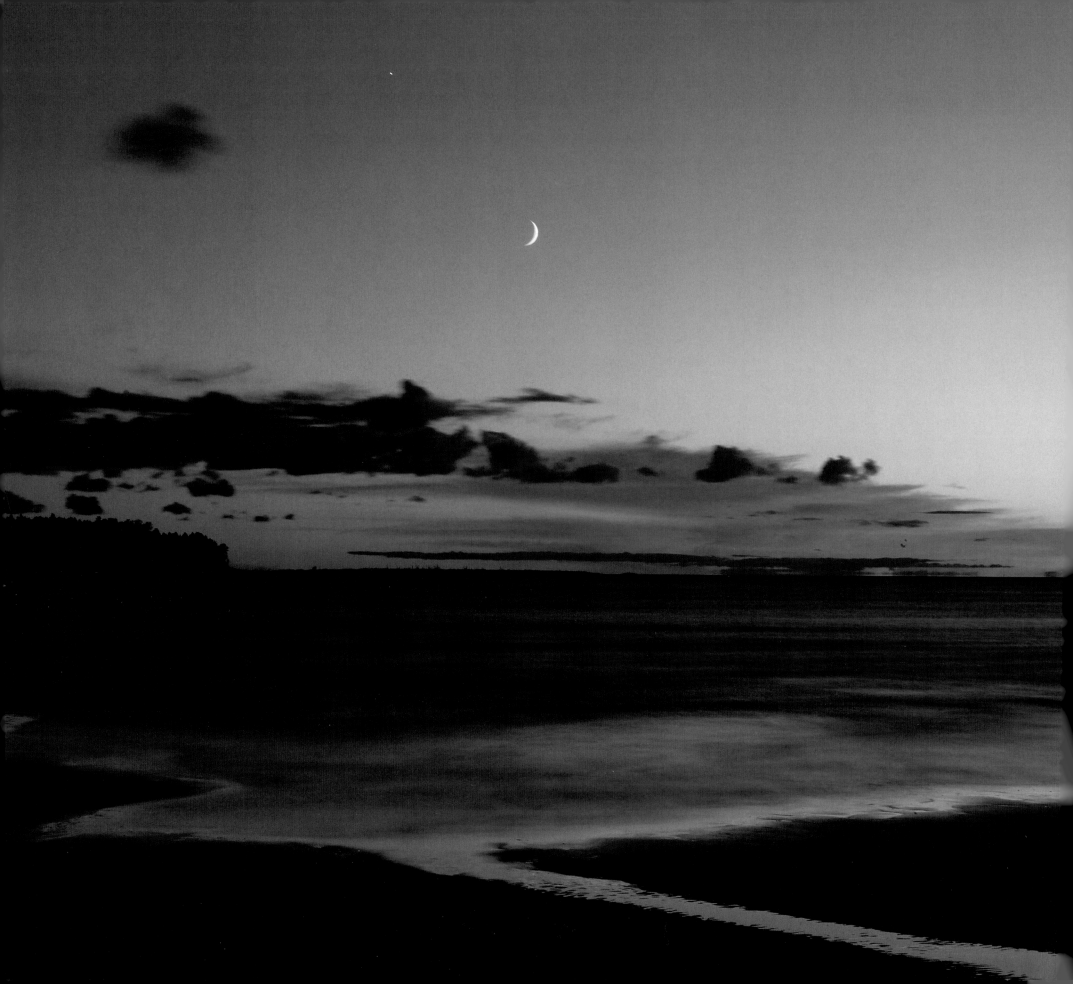

of such selfless and tireless efforts, which I pray might become at some future time a consensus act of love. Already they have curbed the off-road buffoonery of northern cowboys trenching their monster tires into the river mud for no reason other than to test the heft of their power winches. The evidence of logging operations is not insignificant either, but the night terrors of every targeted species have, I suspect, subsided some, and what I have learned from trees, as the poet Denise Levertov says, is patience.

At Pine Stump Junction we took a right and found our way down thirty-five miles of dirt roads and two tracks to the river, its origin of springs and feeder creeks surprisingly low volume, that is if Hemingway has been your guide and the great lie of Nick Adams casting hip deep into a pool of rising brook trout has any bite. "Because that all really happened on the Fox, didn't it?" Lois asked, and I nodded yes, the almost silent peen of raindrops turning coppery all around her, each tiny ring widening and being carried away downstream.

Which is the direction we headed, hoods up, and "in *our* time" the size of the fish seemed unimportant as we waded together maybe two miles before I even tied on a fly, the slate-gray sky occasionally quaking above the slow-flowing river. And there, at the tail end of a certain eddy, I imagined the ghost of someone just back from the war—any war—the leader unfurling in a perfect loop as if to prove that even a world like ours is not necessarily an ugly thing.

I landed half a dozen decent-sized rainbows, but no brook trout, and felt again no imperative urge to undo the myth of

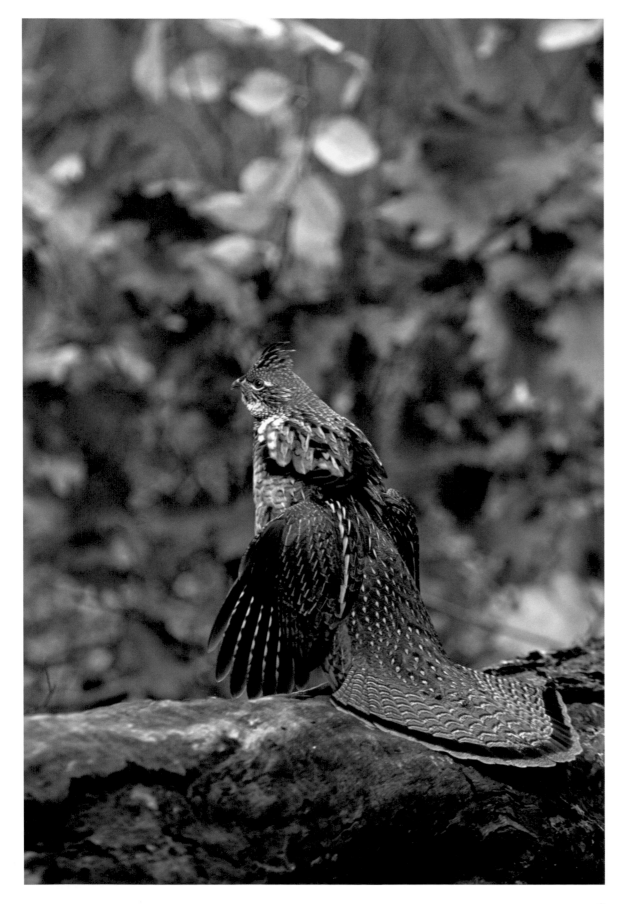

**For me, it is always the woods, the connection of woods and water—a place of renewal. The Two Hearted River is the perfect example, and to help conserve it was so personal to me. It was like a fiftieth anniversary, for my husband courted me by reading Hemingway's beautiful prose.** ∾ Margaret Ann Rieker

those native two pounders. They are the reason I found my way to the Two Hearted in the first place, and they might, in fact, exist, and I don't mean only in story. If someday I land one half that size at dusk I'll find my way to the undercut bank and sit down and smoke that cigar I've been saving my entire adult life for such an occasion. X will mark the spot, though only on a map that exists as an extraordinary memory imprint.

The river is 108 miles long and empties into Lake Superior. Over the past thirty years I have waded substantial stretches of it, Lois fewer but not by far. On certain ones we have heard the mating cries of sandhill cranes, and we have watched them smirk and strut on tiptoe, wing-hunched in their magnificent pantomime among the shadows of jack pine. I know the names of ten different species of cranes, eight of them on the endangered list, and only a mad person would misinterpret that.

And so whenever a jet flies miles overhead I feel blessed to be grounded in a wilder place, where sometimes time might hesitate for a tick or two. Even if we can't, as Heracleitus says, step into the same river twice, maybe Lois and I can find our way back on another day to this Two Hearted sanctuary of simple miracles. Like the almost blue penumbra around the moon some nights, and a few fish rising under a suddenly cloudless sky, and a couple of sojourners packing it in for night, *their* hearts alive and beating yet again in sync. ∾

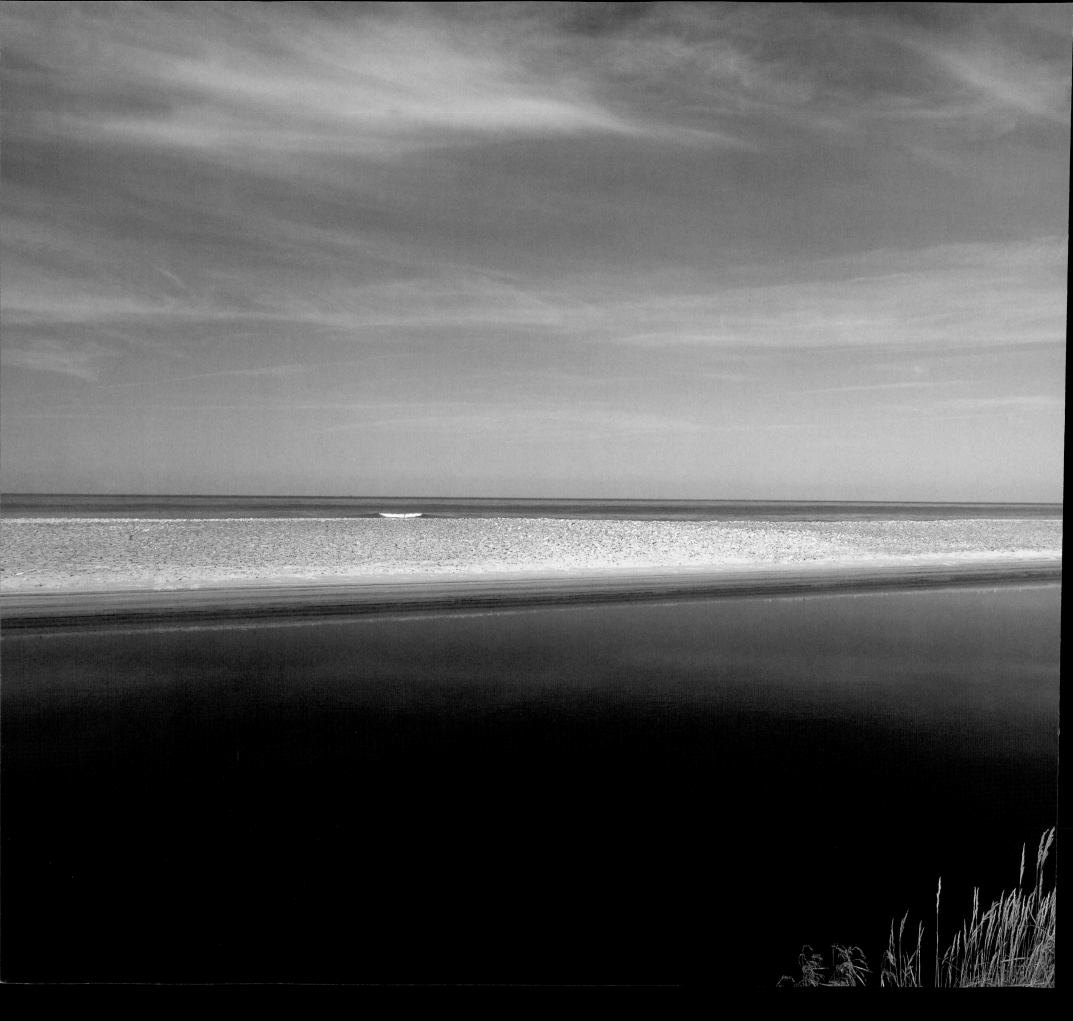

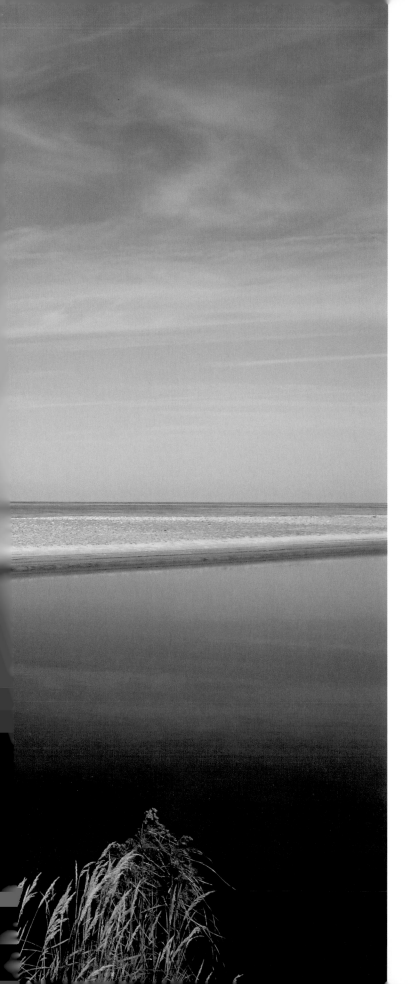

Michigan has over 3,200 miles of Great Lakes shoreline. Areas in yellow indicate The Nature Conservancy's coastal priorities.

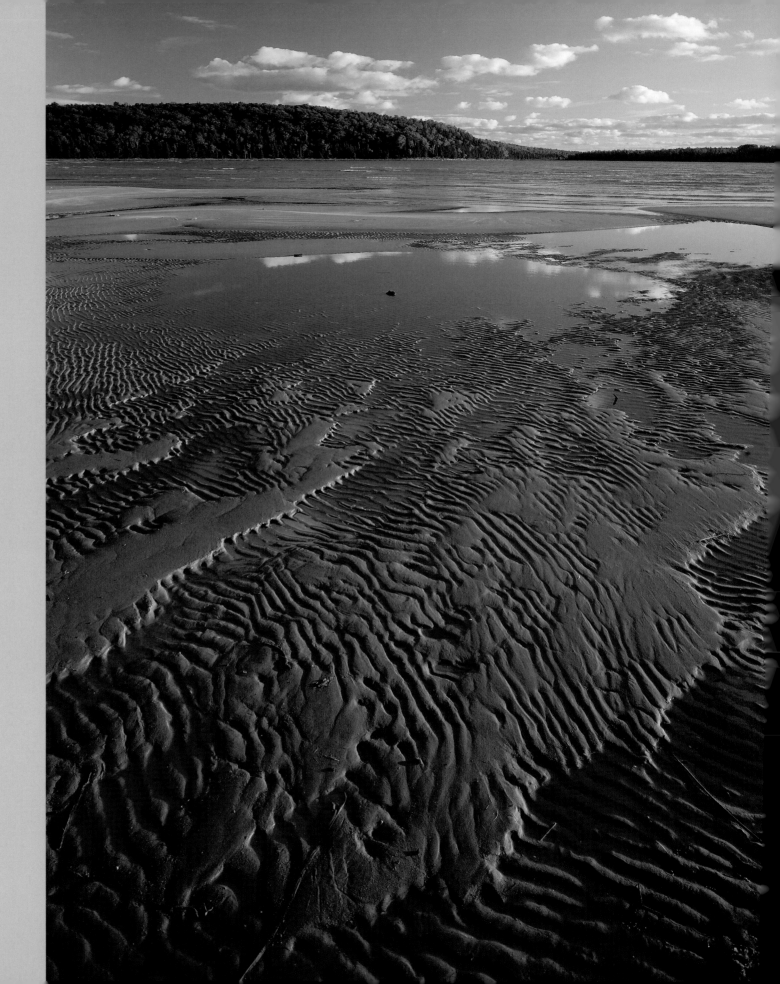

Surrounded by four of the five Great Lakes, Michigan lies at the heart of the largest freshwater ecosystem on earth. Our unique and singular position—defined by two peninsulas and clearly visible from the moon—not only helps to determine the way we live, work, and play in this state; it also gives us a position of privilege and responsibility to the generations that will follow.

Two stunning national lakeshores, the nation's only freshwater national marine sanctuary, and a cornucopia of national and state parks are just a few of the remarkable places provided by Michigan's Great Lakes shoreline. But our splendid shoreline offers more than beauty. It harbors some of the most ecologically rich areas in the Great Lakes region, sheltering globally important habitats and sustaining the health of the Great Lakes as a whole.

Irreplaceable natural features of Michigan's magnificent inland seas include: more than 3,288 miles of shoreline; 275,000 acres of fragile coastal dunes; coastal wetlands that play an important role in processing nutrients and providing food and breeding sites for fish, birds, and waterfowl; 600 islands that supply habitat for plants and animals and critical stopover sites for migrating birds; and rare, limestone-based alvar prairies, a habitat that sustains an uncommon variety of wildflowers, grasses, mosses, and lichens.

With 83 percent of our state's shoreline currently in private hands, the conservation of Michigan's shoreline poses unique challenges for the Conservancy and its many partners. While the need to acquire more shoreline before property values rise dramatically is real, it is also necessary to develop new public resources and opportunities for building conservation partnerships that will protect our incomparable Great Lakes heritage for coming generations.

# *Shoreline*

Why do I love the shoreline of the Great Lakes? It is overwhelming in its beauty and power, yet restful. That's an unusual combination—to be so powerful and so restful.

∞ Senator Carl Levin

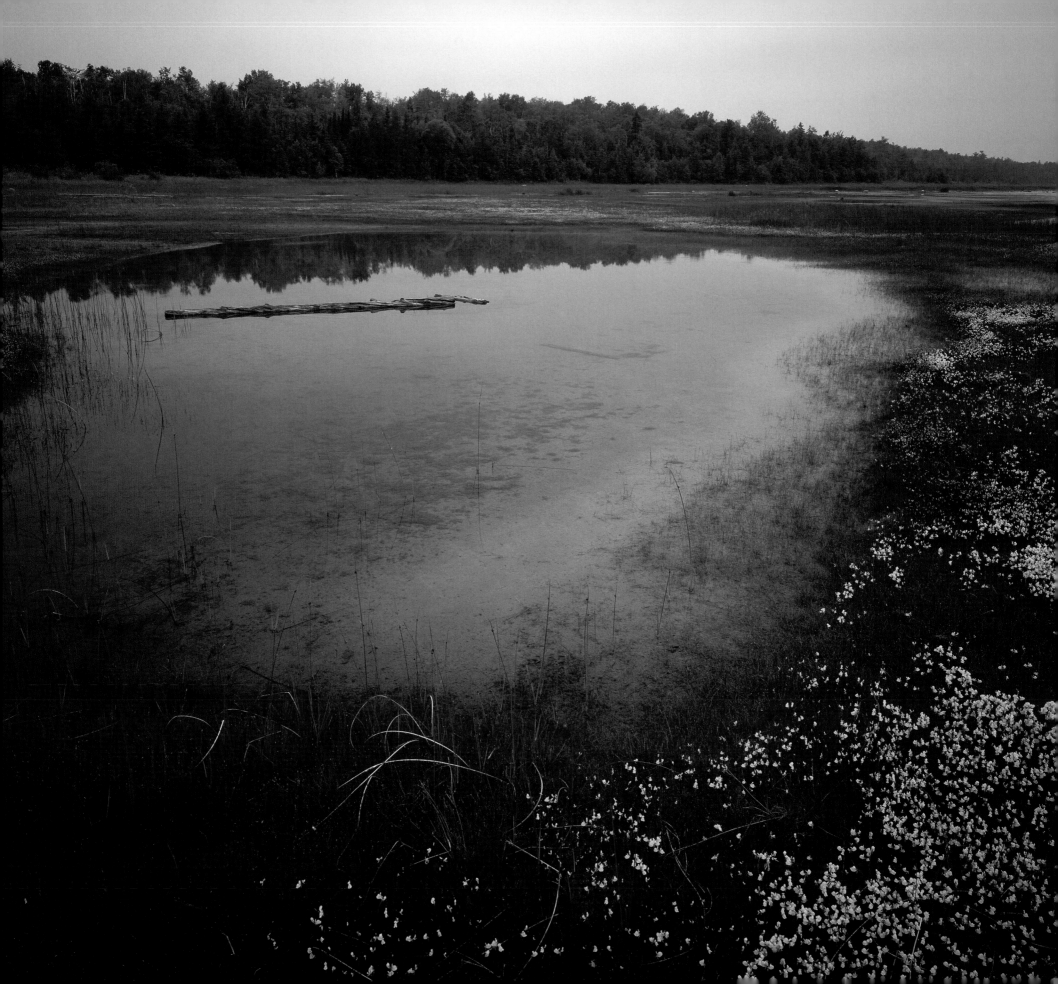

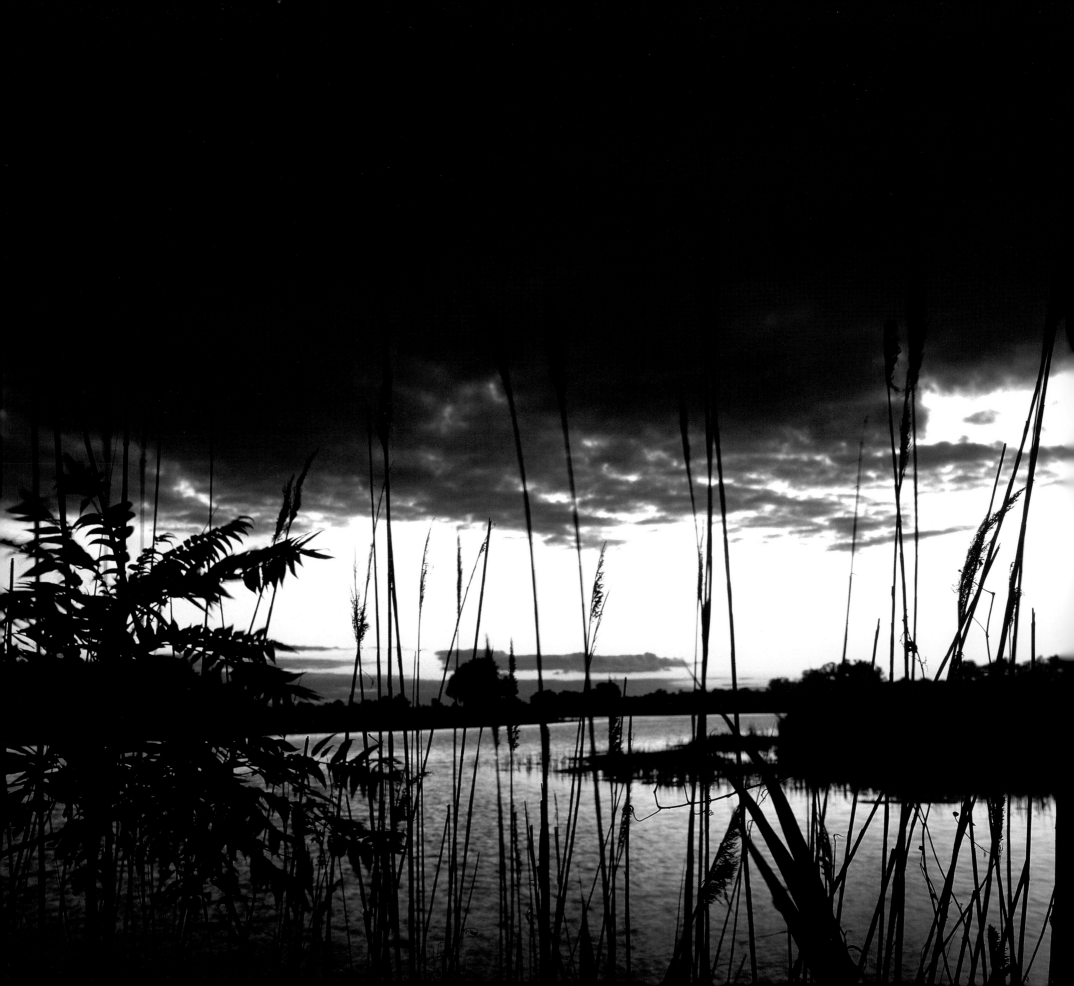

The approach to Erie Marsh Preserve in early spring makes your head spin. Overhead, thousands of ducks are rising, circling, and weaving over the marshes—northern pintails, mallards, blue-winged teal. Across a ditch, pumps are thumping, spewing water into a channel. An eagle lands in a distant cottonwood; right here, a grader rolls by, scraping the dike. Erie Marsh offers magnificent, and mixed, messages.

Every which way, you're in the midst of the natural drama of migration, with its sky choreography, flamboyant displays, and on-the-ground camouflages.

At the same time, you're in the midst of a managed and mechanized landscape—dikes, water control structures, pumps, plows, disks, graders, tractors, four-wheelers, backhoes. The machinery of reclamation and restoration runs full tilt.

At Erie Marsh Preserve, nothing is simple. You understand immediately—this is not wilderness. Untouched, pristine places are somewhere else. Not here in Southeast Michigan on the shoreline of Lake Erie.

Erie Marsh is a postindustrial restoration, important to see for that reason, for its layers of loss and recovery, as well as for the panorama of the waterfowl, the Great Sulphur Spring, and the rare American lotus beds.

Walk the grid of interior dikes and you see the half of Erie Marsh Preserve that is marshland—sectioned, enclosed, and maintained by artificial drainage. Walk the perimeter dike and look toward Toledo and you see the half of the preserve that is open Lake Erie waters, a section of North Maumee Bay, where on this particular morning hooded mergansers are hanging out, diving for fish.

The story of the Erie Marsh Preserve is elemental and dramatic—a story of the intersections of air and migratory flyways; of earth and marsh and lake plain; and under and through it all water, water, water. It's a story webbed with human intervention. A multiple, layered, overlapping plot. The landscape may not be pristine, not wilderness. But it's wild!

The Erie Marsh you see today has been hauled back from the brink with machinery and multiple restorations.

Until you look at early maps of western Lake Erie and Southeast Michigan, where marshes are noted with crosshatching, it's hard to imagine the look of the place before European settlement. Western Lake Erie was rimmed with marshes, mile after mile interspersed with barrier islands near shore where Native Americans fished and hunted. And, most startling to imagine, these marshes stretched miles inland, sometimes dozens of miles inland, a shifting landscape of low dunes and swales.

JANET KAUFFMAN *Erie Marsh*

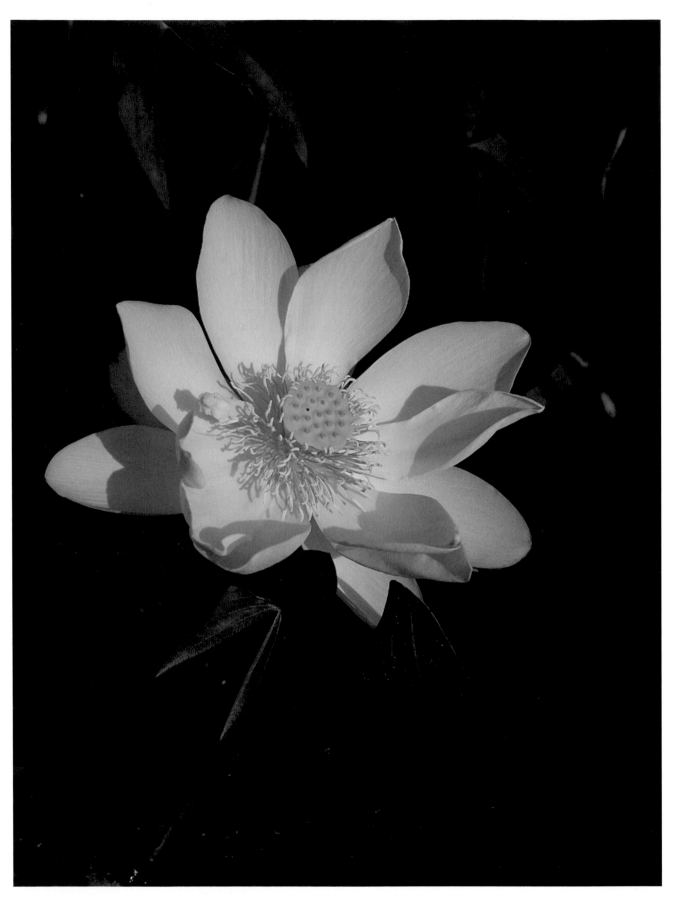

Ninety percent of these marshes are gone—drained or filled or eroded and washed away. The 2,100 acres of Erie Marsh Preserve are a critical remnant. This one preserve protects 11 percent of Southeast Michigan's remaining marshlands.

The preserve is also one of several protected areas within the 48-mile-long Detroit River International Wildlife Refuge, created at the intersection of the Atlantic and Mississippi migratory flyways. Erie Marsh is a key parcel in the refuge, one of the top ten biodiversity habitats in this heavily populated area.

Within the international refuge, 7 million people cohabit with 27 species of waterfowl—including 60 percent of the world's canvasback ducks in the fall migration—17 species of raptors, and 117 species of fish, and that's not counting the songbirds, the bugs, and all the other wildlife and plants native to the Lake Erie marshes and lake plain.

It's not easy to hold complex habitats together—to live and let live in this changing water world. Erie Marsh has had plenty of near-death experiences, plenty of close calls.

In the beginning, the story of Erie Marsh is a lullaby of a narrative. Nothing happens at Erie Marsh without the lake, the swoosh of its shallow waters at this western end. Creek flows carry water into the lake, and wind patterns push the ebb and flow—seiches—shore to shore. The marshes, hundreds of thousands of acres, buffer the shifts, the rise and fall of the lake that is the life of the place.

Or the marshes *would* buffer, without interference. Erie Marsh took its first human hit with the construction of the Detroit-Toledo Railroad in 1858. Then two more railroad lines by 1898, each one cutting through the marshes, the track laid on causeways, high and dry, like dams backstopping the lake, the first of many hard shoreline structures. The marshes lost the ebb and flow of Lake Erie waters. Hemmed in, the seiches that nourished the marshes washed in and out with greater intensity; they uprooted vegetation, eroded edges, and degraded the marshes they once fed.

Interior wetlands could not be refreshed. Within a few decades, the cutoff lake plain was ditched and drained for agriculture, and the lake's coastal marshes eroded almost completely.

But a few marsh remnants were spared, often saved by the last-ditch efforts of duck hunters. Erie Marsh is one of the largest of these hunt club rescues. The Erie Shooting and Fishing Club, founded in 1870, was a small group of hunters determined to keep waterfowl in their sights, which meant restoring the marshes with artificial dikes and replacing lost forage.

In the early 1950s members of the club constructed a protective perimeter dike and soon after added interior dikes so they could flood and drain the marshes, reintroducing the ebb and flow of the shoreline seasonally. In spring they pumped water out, over the dikes and into Lake Erie, planted corn, millet, and buckwheat in the dry ground, then flooded the fields during the fall migration for duck hunting.

It's been a huge reclamation effort to this day. The railroads were only the first of many affronts to the marshes; next came roads, built closer to the lake, then the Whiting power plant just to the north on the shore, with dredging for intake lines and more spoil going into more dikes. In 1958, the I–75 freeway cut so close to the Erie Marsh that you can stand on the dikes of the preserve and watch the trucks go by. After more dredging, and more dumping of spoil on dikes twenty years ago, the invasive reed *Phragmites australis* took hold, overwhelming native plants throughout the marsh.

The club, whose historic hunting cabins line the gravel parking lot, still holds a lease on the diked part of Erie Marsh Preserve and works with The Nature Conservancy and Ducks Unlimited on restoration projects. The current president says one restoration goal is to "wean ducks from farming practices" and bring back native grains to the marshes. That means, first of all, eliminating the invasive *Phragmites*.

"You can't manage here using a natural model," says a Conservancy representative. And, no doubt about it, current restoration projects at Erie Marsh get downright extreme, with the cinematic effects of prescribed burning, then spraying, then drowning—an action sequence to control *Phragmites* that's proven very effective in the 83-acre Widgeon Hole quadrant of the marsh.

Preservation and restoration practices still depend on the dike system, on draining and pumping to mimic the original

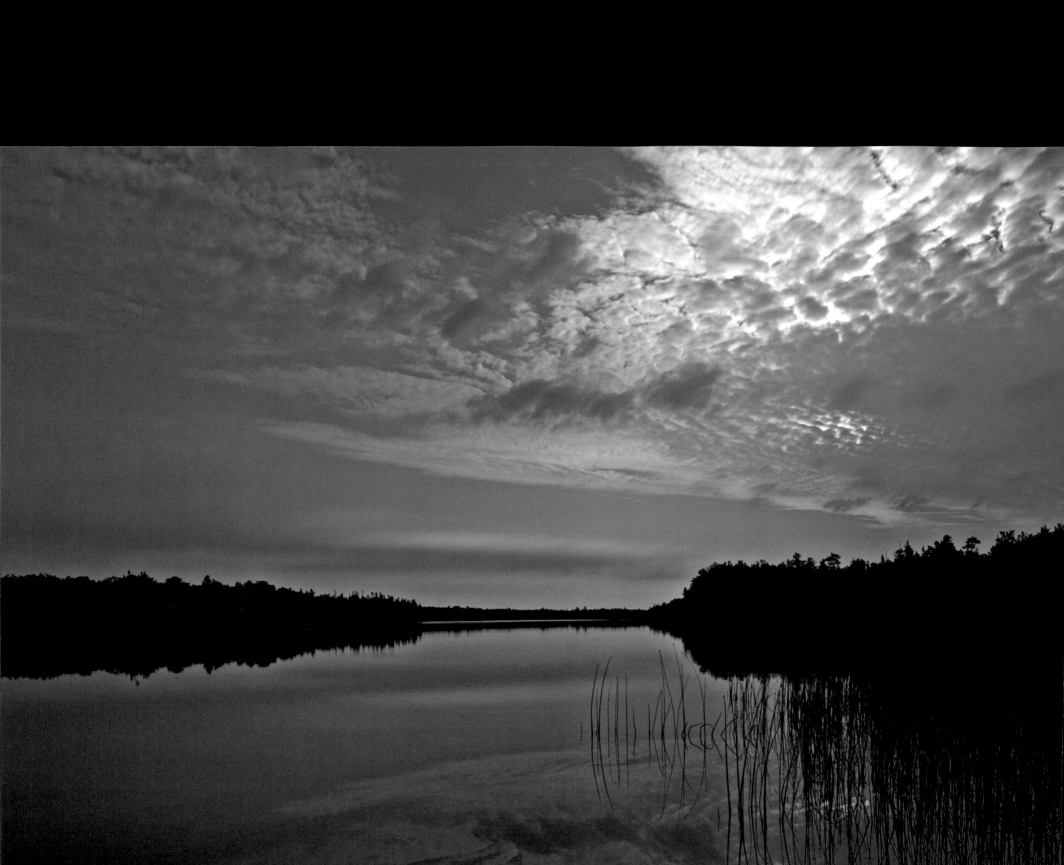

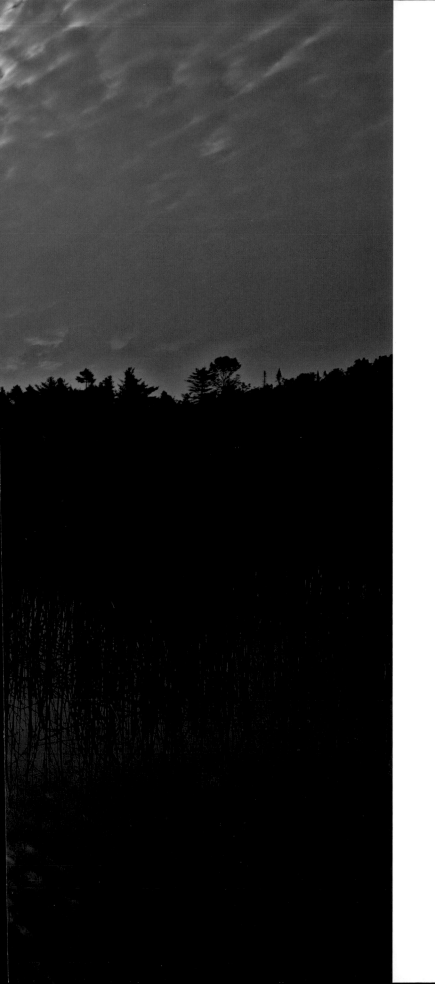

> **All that is precious, all that is part of an ecosystem that's water, plants, birds, fish, animals, and insects: it all works together to make Erie Marsh a wonderful place, a unique place in the world.**
>
> ∞ Congressman John Dingell

marshes, an artificial cycle that clearly works for waterfowl.

Still, if you walk the dikes past Widgeon Hole, you come across one wholly natural wonder (you can smell it!) and numerous native species making a comeback.

The natural wonder, at the center of the marsh, is the Great Sulphur Spring. The earliest maps of western Lake Erie show the Great Sulphur Spring as a large circle, which probably then, as now, was colorful, stinking, bubbling up, and flowing in the open marsh. The rim of the spring is edged with calcareous deposits and a painterly algal wash of reds, blues, purples, and greens. Birders know it's a place to find dabbling ducks even in fierce winters; the Great Sulphur Spring never freezes. Water chemistry has identified the source of the spring as a Silurian bedrock aquifer. The water rising in that spring is over 400 million years old.

Along the perimeter dikes, some native species have not only returned but made a dramatic comeback in recent years. The eastern fox snake, a threatened species in Michigan, can now be found here.

And, most dramatic visually, the American lotus (*Nelumbo lutea*), America's largest aquatic wildflower, thrives on the eastern shore of the perimeter dike. Pale yellow, with the fragrance of jasmine, the lotus flourished historically in beds a half mile wide. Both the leaves and the flowers rise out of the water on tall stalks. In the dense beds, the leaves grow round and extremely wide, sometimes 2 feet across—birds can walk easily across them.

The lotus beds are an ecosystem in themselves. Muskrats build houses in the lotus beds; butterflies and swallows feed in the flowers; small fish hide out in the root structures, tail to nose, a safe nursery.

The lotus beds have always attracted humans as well. Native Americans ate the seed or cracked and ground the seed into flour. And in the early days of European settlement the lotus beds were a major tourist attraction, with canoes carrying sightseers offshore, floating them under gigantic leaves and flowers.

No matter the awe, with the hardening of the shoreline in the early 1900s the American lotus declined and almost disappeared. A species of special concern in Michigan now, the lotus is returning as marshes are restored. In 2004, through the efforts of the Monroe Lotus Garden Club, the American lotus was designated Michigan's state symbol for clean water.

The long walk to the lotus beds is one of the best walks you can take in midsummer at the preserve. Head out the old perimeter dike past the maintenance buildings. With the marsh on one side and the open North Maumee Bay on the other, it's an excellent bird walk—waterfowl, songbirds all along the way. Arrow arum (*Peltandra virginica*) pierces the water, swaths of it in the marsh and in the bay, dark green leaves pointed straight up. There's a good chance of seeing eagles or ospreys, or the rare fox snake, protected in the preserve.

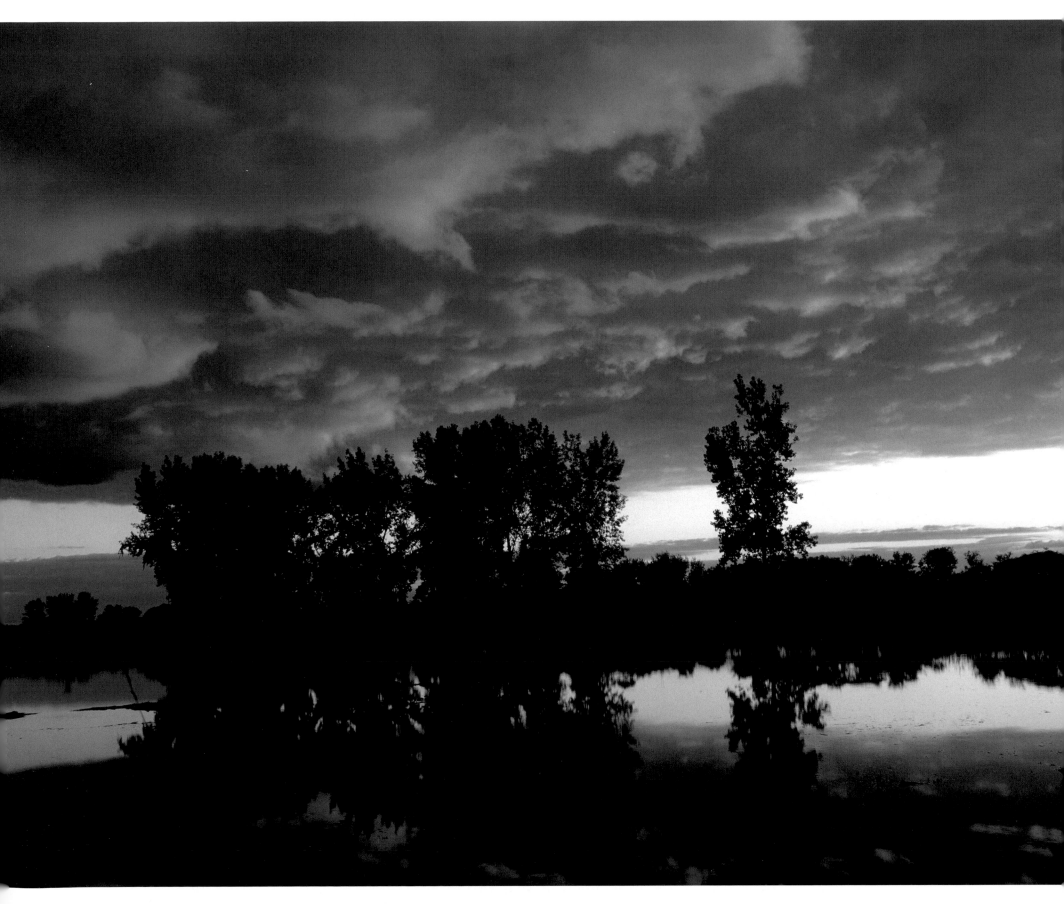

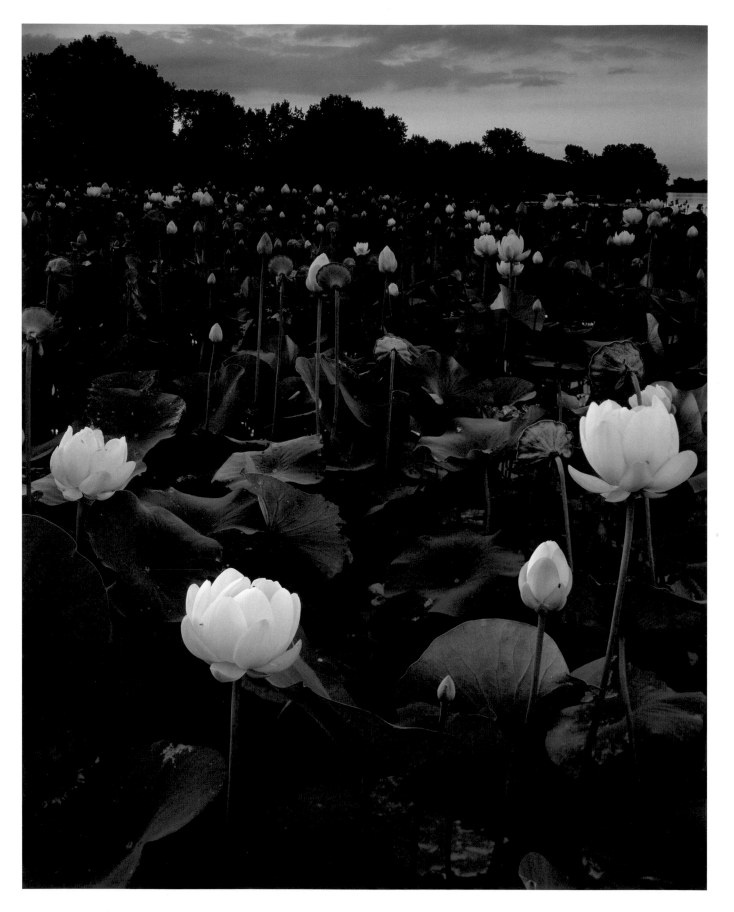

At the east end of the dike, through the last and largest trees at the shore, walk right to the edge of the water and there they are—the lotus beds with big bud stalks rising in June, the huge flowers opening near the end of July.

Another story of recovery in Erie Marsh Preserve lies beyond the perimeter dike, beyond the lotus beds, in the preserve's other half, the open water of North Maumee Bay.

It's a fish story, and it may be the richest recovery. In 2005, Michigan's Department of Natural Resources and the U.S. Fish and Wildlife Service surveyed western Lake Erie sites and found huge species diversity—45 different species at 4 sites in the preserve. The near shore is a nursery and forage area, a critical production site for Lake Erie. It's important seasonally for walleye, emerald shiners, spottail shiners, yellow perch, and pumpkinseed sunfish. In spring, the young hatch and feed close to shore, before heading out to the open waters of the lake.

At Erie Marsh, what you see is recovery-in-process. You see the comings and goings of hundreds of ducks, geese, herons, egrets, shorebirds on mudflats, the aquatic flora— the richness of this recovery. But just as interesting is what's not there, the past, the losses only glimpsed in fragments, bits, riprap, remnants. You catch a glimpse of the Paleozoic in the Great Sulphur Spring, a hint of the original hundreds of thousands of acres of marshes in the arrow arum and lotus beds. The industrial past that nearly killed the marshes is still there, its machines turned now to protection of the wetlands.

At Erie Marsh, you can't kick back and say, *Ah! Wilderness*. While the losses to Lake Erie's marshes have been grievous, at Erie Marsh Preserve you can marvel at the work of reclamation. You can marvel at the diversity, at so much given a second chance—canvasbacks, emerald shiners, American lotus, rose mallow, eagles and fox snakes, kingbirds and kingfishers—in a wild, disconcerting, surreal, and magnificent marsh. ∞

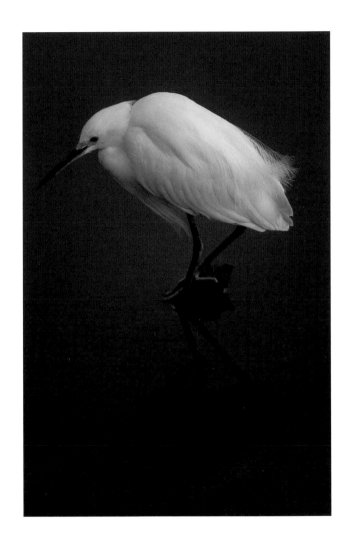

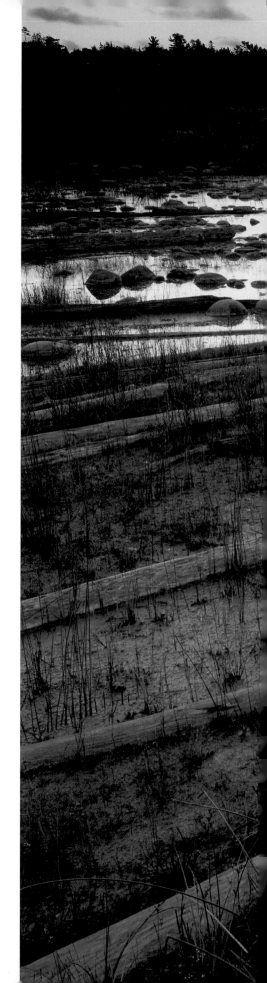

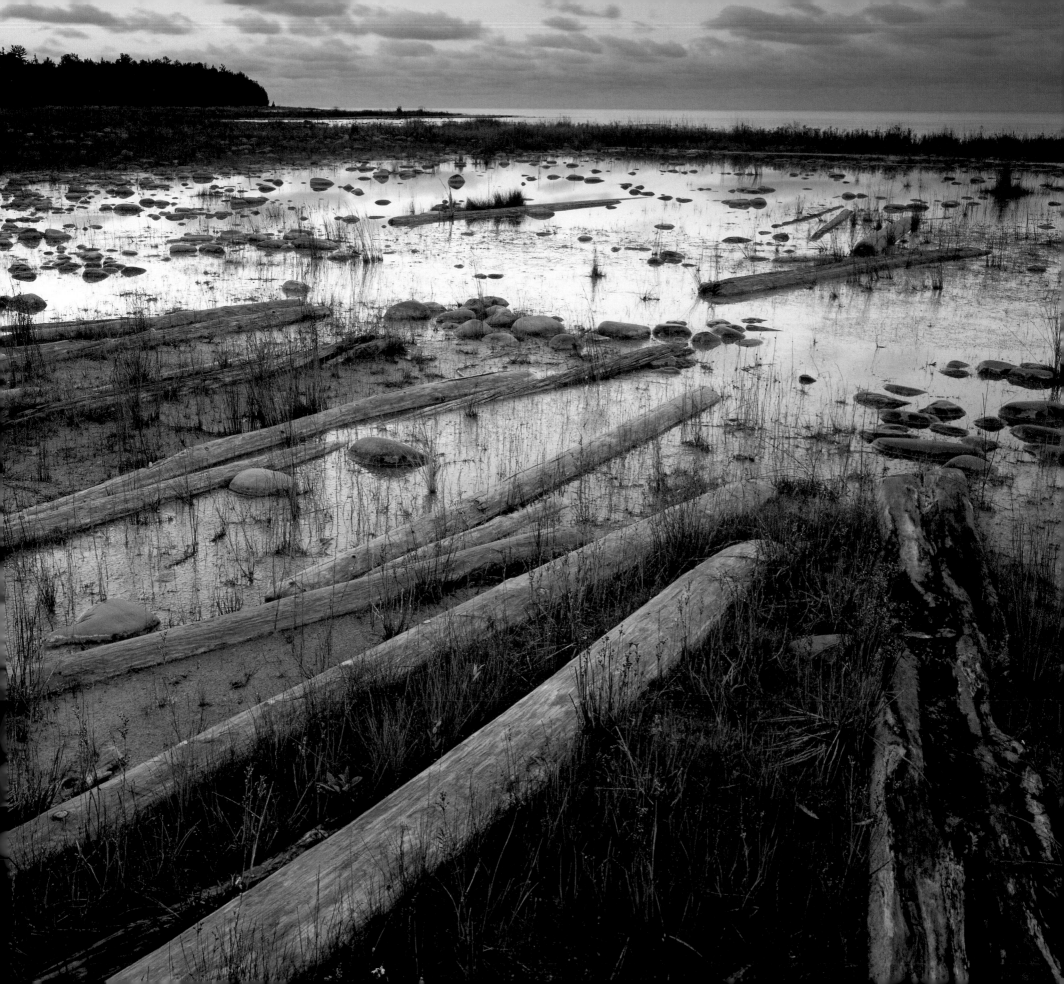

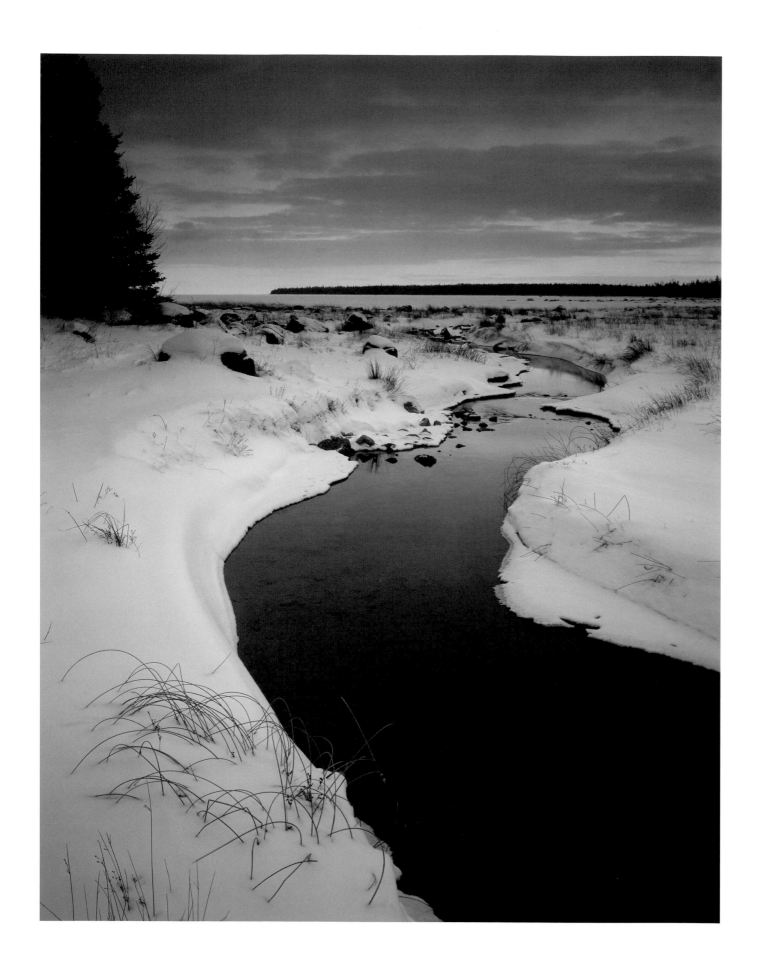

The trip begins badly, with a shameful secret: I'm not prepared. My work life has been more than usually hectic these last couple of weeks, despite the fact that I'm supposed to be on summer "vacation." When Tony and I head up I–75 from Ann Arbor on July 6, the hood of our minivan pointed toward the Mackinac Bridge, I'm in a kind of panic. I'm not a naturalist, although I value the natural world above almost everything else, and I've only just started reading books and pamphlets about Les Cheneaux, a group of thirty-six islands on the northern shore of Lake Huron. At least we have a place to stay. Judy, owner of a group of mainland shoreline cottages she calls "A Wee Bit of Heaven," informs me on the phone that she happens to have one cottage open between family reunions. When I explain that I'm a writer doing a piece for The Nature Conservancy, she tells me we can have a discount. "We need more people writing about Les Cheneaux. On second thought, you can stay for free."

As the highway slides through forests of hardwood, then birch and spruce, I console myself with the warmth of her welcome. Actually, it's hard to be discouraged long on this sparkling summer morning. I haven't been to the Upper Peninsula since I was thirteen, and Tony, at nine, is at least as excited as I am. Long before getting there, however, we stop for lunch at a German diner in Frankenmuth; over a gooey salad I explain to him that The Nature Conservancy and its local partners have protected nearly 5,000 acres of wilderness in the Les Cheneaux area, including more than eight miles of shoreline, and that many people believe the name of the region is from an old French word for "channels." The rest we'll have to find out together.

Several hours later, we're driving over the bridge, high above the late-afternoon glitter of water, with a view of the Grand Hotel on Mackinac Island. The islands lie beyond that, to the northeast, and we can already see a haze of land there on the southern edge of the Upper Peninsula. That's our destination. North of the bridge, we take a right onto Route 134 and head east not far from the Lake Huron shore, then into winding roads lined with woods and modest summer cottages. Judy welcomes us kindly and shows us to our cottage, with its heavy flowered drapes and bedspreads, explaining that there's a Danish family reunion in the other cottages at the moment. By the time the moon rises, we're sitting on the channel shore, watching some of the guests cast lines off the dock. The water is turning lavender, the sky golden. One little wooden motorboat goes by with two gray-haired people, a man and a woman, standing up very straight together at the helm. Then peace again. Tony plays soccer with some of the younger Danes.

ELIZABETH KOSTOVA *Journey to Les Cheneaux*

**We are truly blessed in Michigan with wonderful natural resources that have provided beauty and enjoyment for generations. From the shores of the Keweenaw Peninsula to the Erie Marsh Preserve, The Nature Conservancy has served as a true steward of our natural treasures. Following their example, we must all continue to protect and enrich our environment. Michigan is a special place that we must preserve for future generations.** ∾ Senator Debbie Stabenow

Under the deepening wash of moonlight, we can see and hear rippling water everywhere—*les cheneaux*—and looming beyond that the dark shores of other islands, crowding too close to one another in places for us to count them. Somewhere beyond them is Lake Huron itself. Another boat putters by; a dog barks from a house up the road; someone recasts a line into the water with a heavy splat. As we find our way sleepily back up to our cottage, the other guests are singing Danish songs on their candlelit porch. In our cabin, I get out those books and pamphlets and settle in to study the area's human history.

Les Cheneaux, or "The Snows," as early English-speaking settlers called it, mishearing the old French name, contains about 175 miles of shoreline and a multitude of different natural habitats, ranging from Great Lakes marshes to coastal dunes to cedar forests. Much of the shoreline includes important stopover habitat for migratory birds. Long a territory of the Ojibwa tribes, the Les Cheneaux area was first infiltrated by French trappers, then French and English settlers. (Philip Pittman, a historian of the islands, has laid out the saga of its fishermen and farmers in two wonderfully detailed volumes.) In the nineteenth century, Les Cheneaux became a major lakeside resort, boasting majestic Victorian hotels. Today it is home to about 3,000 year-round residents, a population that swells to as much as 20,000 in the summer. Apart from its tourism, Les Cheneaux was and is a fishing community, famous for muskies, pike, perch, and bass, although the industry has declined hugely with the decline in the fish

populations. Now The Nature Conservancy and its regional partners, including the Little Traverse Conservancy, hope to conserve the region's wild areas in the face of increasing pressure from new vacation homes. Somewhere, out beyond our cabin, those acres they've already protected are burgeoning with life, with the sounds of the night, protected for posterity.

We sleep like a pair of logs.

≈≈≈

The next morning, we meet Nadine for breakfast at a diner in Cedarville. Nadine is a pretty, blue-eyed woman, a recently retired school principal who has been a volunteer for The Nature Conservancy for several years. Over eggs and coffee, she tells us the story of her defection to Les Cheneaux: "I first came here years ago as a summer volunteer from downstate helping to restore a one-room schoolhouse on Lime Island in the Saint Marys River. I visited the area a couple of times, and then one day I was driving down 134 and I thought, 'Wait a minute, this is almost like being in love. I mean, *this is it*.'"

She called the superintendent of schools for the Les Cheneaux region, and he said, "Well, why don't you come on up and we'll find something for you." She's been here year-round ever since. "As a Conservancy steward," she said, "I watch for and help to guard endangered plants. There are a lot of rare wildflowers here—ram's head orchids, dwarf lake iris, Pitcher's thistle. I organize volunteer workdays to help control invasive species. I try to save rare plants from roadside mowing. And I see firsthand what I believe is evidence

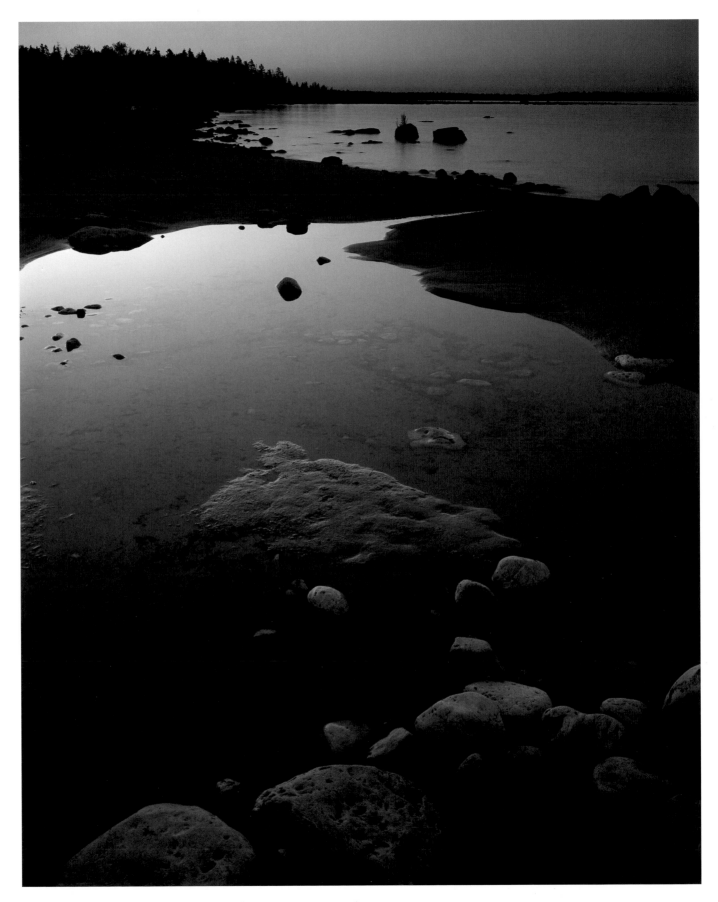

of global warming: some of the wetlands I visit are actually drying up. Also, the lakes aren't freezing over the way they used to." I ask her about overfishing, and she says readily that it has been a serious problem for Les Cheneaux, both for the fish and for the local fishing and tourist industries. Sometimes double-crested cormorants are blamed for the drop in the fish population, and 100,000 cormorant eggs were oiled last year in a federal project to prevent their hatching. But there's no doubt, she tells us, that overfishing has been a huge problem here down the decades.

As we finish our toast, Nadine asks the teenaged waitress what she likes best about living in Les Cheneaux. "The quietness," says the girl immediately, refilling our water glasses. "It's peaceful."

~~~

Under Nadine's guidance, we visit the Les Cheneaux Historical Museum, whose curator shows us a wealth of photographs of the islands' past—Tony particularly likes one of a local fisherman measuring himself next to his catch, a seven-foot sturgeon—and then we spend the rest of the day on the water. A realtor active in local conservation has borrowed a pontoon boat to show us around; we get a tour of the main channels of the islands, the nineteenth-century cottages that line some of the shores, and a distant view of marshes and long stretches of unbroken forest along the water. The Nature Conservancy and the Little Traverse Conservancy collaborate to protect land on Marquette Island, Les Cheneaux's largest. The island is home to the Aldo Leopold Preserve—more than 1,000 acres, including three miles of Lake Huron shoreline, named for the ecologist and author of *A Sand County Almanac*, who spent boyhood summer vacations in Les Cheneaux.

We can't steer very close to shore in the pontoon boat, but that evening we get another unexpected view from the water. We're sitting on the pier near our cabin when Nadine and a second local realtor suddenly pull up in the most beautiful antique wooden motorboat I've ever seen. It gleams in the dusk. "Want to see the islands at sunset?" Nadine calls from the passenger seat, and we put on life vests and clamber aboard.

Our host boats with the exuberance of a skilled teenager in a beautiful sports car, skimming along the channels as dusk falls. He knows every inch of these shorelines and the cottages he sells, sometimes to immensely wealthy heirs of industry—"But you wouldn't know them from anyone else. And some of them really support conservation here." Modesty of style is so valued in Les Cheneaux, he asserts, that when people sell a cottage they often leave behind "cottage clothes," which come with the house. He skids to a stop in the middle of a bay—the water is turning violet under us—and points out a part of Marquette Island where the conservancy partners hope to protect more land. On the way back, he lets Tony steer.

Seeing the islands from the water has been wonderful, but I'm starting to want to get to the heart of those preserves, and it's almost a relief when Nadine picks us up the next

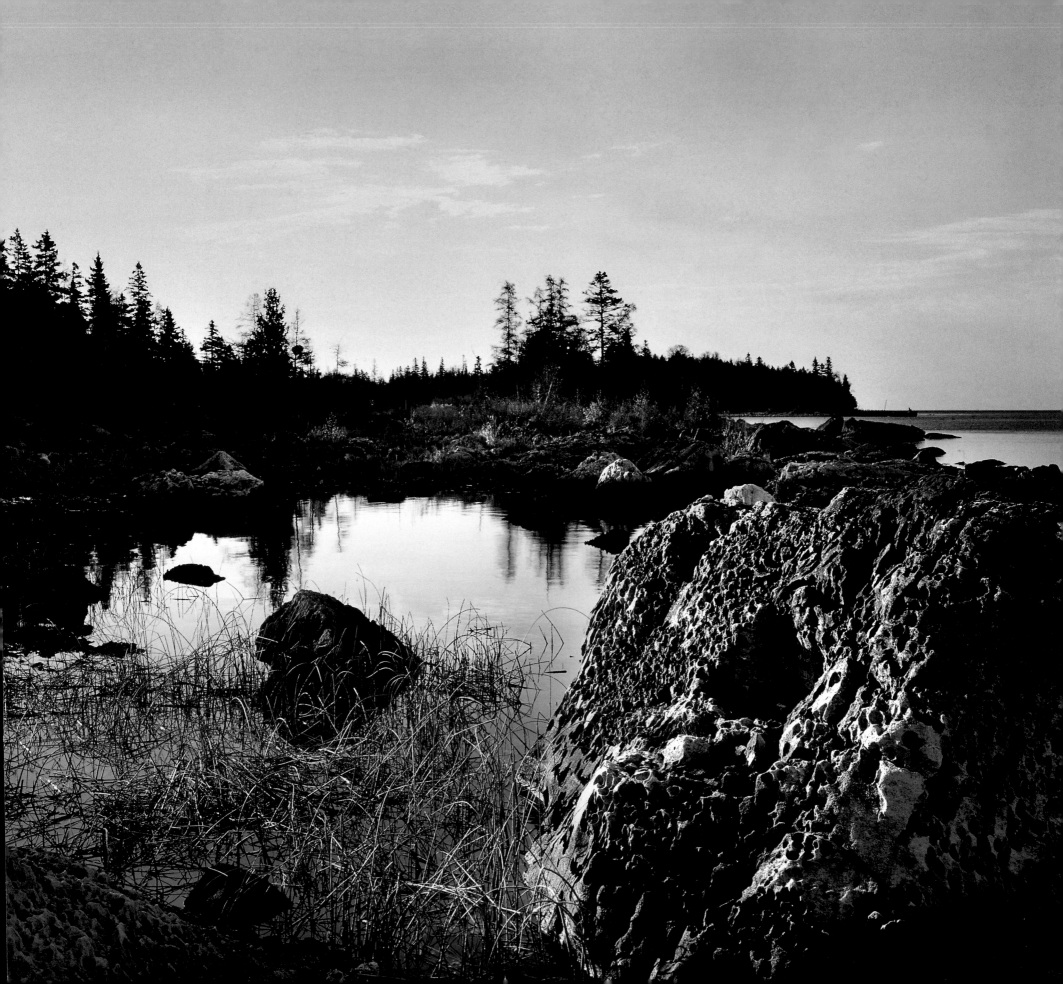

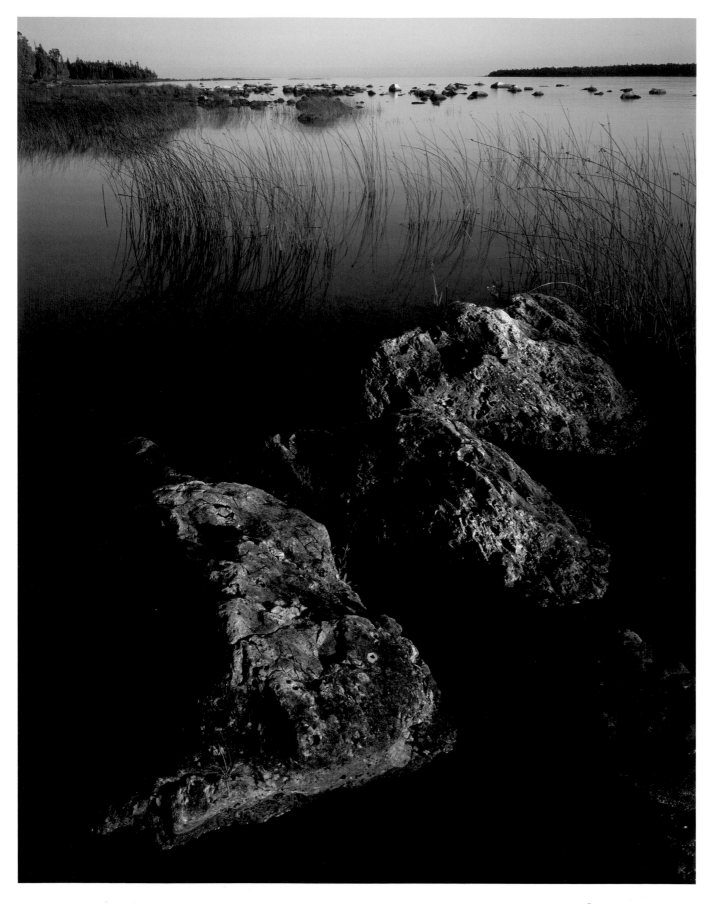

morning and drives us along Lake Huron to a sign that reads, "Eight Miles of Magnificent Shoreline protected for you today and for generations to come." We stop at Stevenson's Bay—a tawny beach with slow waves coming in, tall thistles, lake and sky the same rimless silver. This is the northern Lake Huron shoreline within the Conservancy's Carl A. Gerstacker Preserve. Nadine leans down to the sand and points out what she says is probably a wolf track; I'd give a lot to catch Tony's face on camera at that moment.

Eventually we cross the road and make our way deeper into the preserve. "It makes me so mad that they mow the roadsides just as the wildflowers are seeding," says Nadine. The trail takes us first through open meadow, then into a treasure-house of trees and flowers: cedar, larch, juniper, white pine, white spruce, bracken fern, harebell. Nadine points out the inverted hills of ant lions, insects that trap their prey by making holes for it to fall into. We're actually walking on sand dunes, now forested, with wetlands between them. One of the great conservation needs in the islands is to protect woods like this, up to 1,000 feet from shore—the habitat of migrating redstart warblers. We pass Canadian anemone and low blueberry bushes. I don't know if I've ever seen a more beautiful, more delicately wooded trail. Nadine leads us down into a wetland; this one is man-made, a "borrow pit" that provided dirt for the building of Route 134 in the 1930s. There are long streaks of water capturing the sun there, and Tony finds a tiny frog. "And *that*," Nadine says, "is probably moose scat."

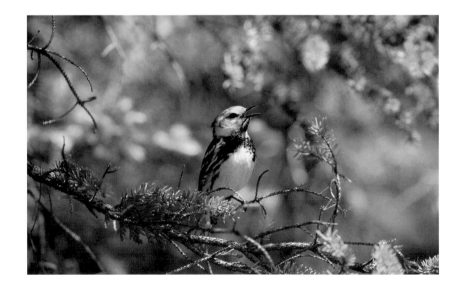

This time I'm glad I don't have my camera ready. I just want to look at Tony's smile, not through a lens but through the dappled, reflected sunlight. At his insistence, I bend over to examine the little pile of primeval droppings, souvenir of a great creature that passed unseen through these woods some-time in the last two or three days. The woods are warm and moving around us, and there's a lump in my throat. The land we're crouching on has been preserved not only for its woodland fauna and flora and for us but also for Tony's great-great-great-grandchildren, children he and I will never see, with their similar bright eyes, their smiles subtly related to his. Nadine grins. "That's a thrill, isn't it?" And we both nod—yes. ∾

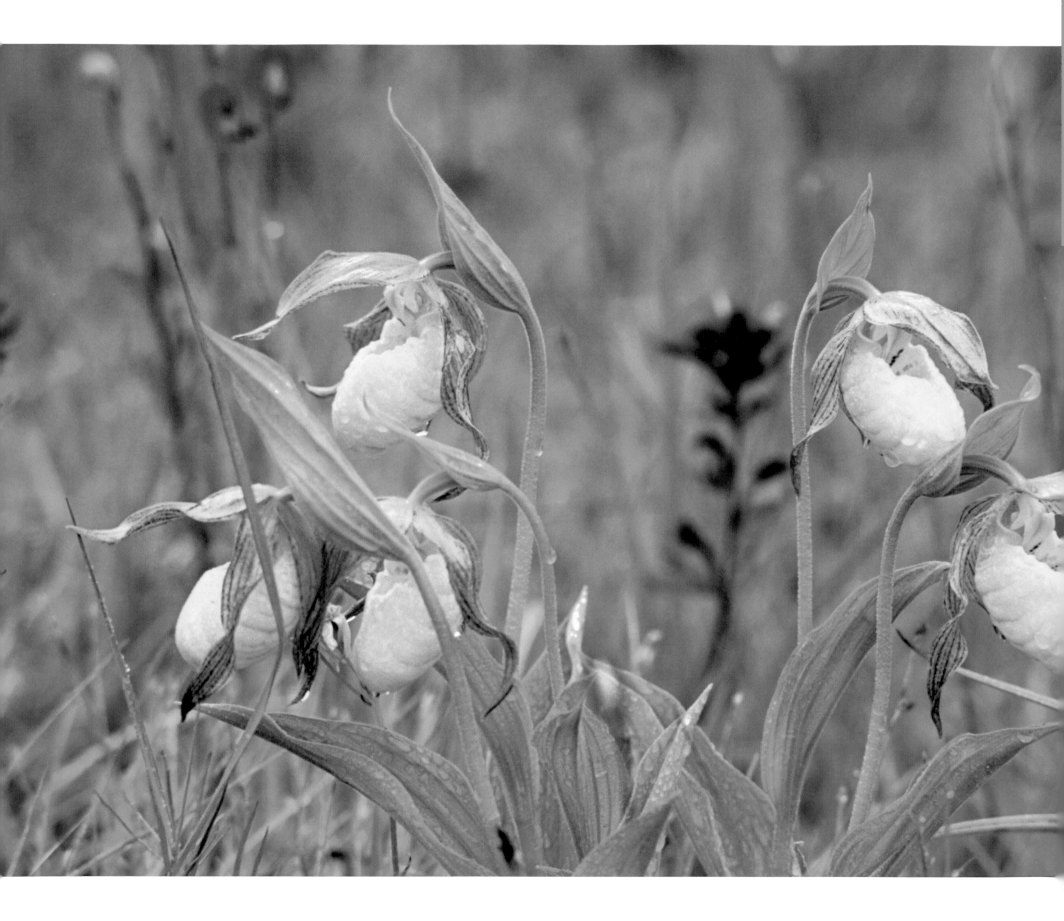

As I travel around the country and the world I see many beautiful places, but there's no place I'd rather be than in Michigan, my home. Our incredible lakes, streams, forests, wildlife, and natural beauty are loved and appreciated by all who live here. And, thankfully, these natural wonders are protected by the important work of The Nature Conservancy. ∞ David Brandon

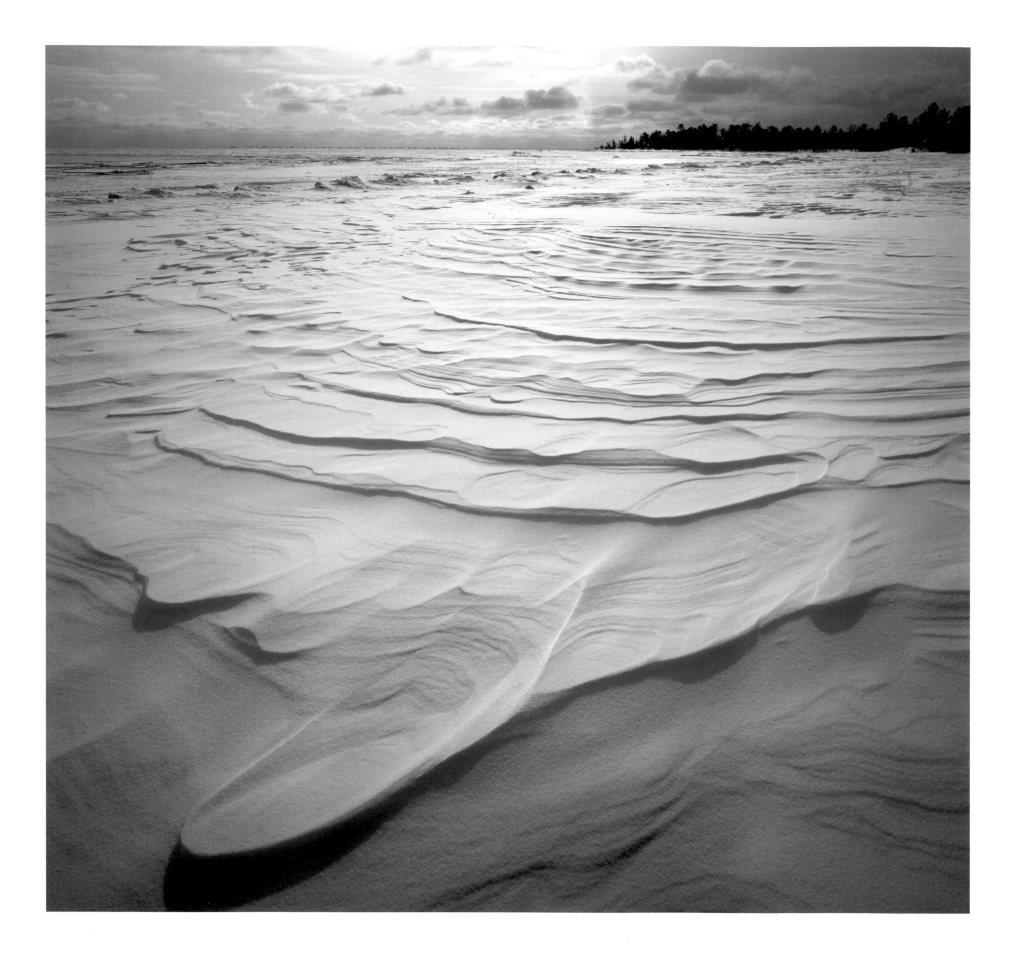

What would the world be, once bereft
Of wet and of wildness? Let them be left,
O let them be left, wildness and wet;
Long live the weeds and the wilderness yet.
— Gerard Manley Hopkins, *Inversnaid*

We human beings are as powerfully attracted as amphibians, moose, mosquitoes, and swamp roses are to the wild places where land and water meet and mingle. Our kind, however, tends to want to settle by estuaries or shorelines without having to tolerate miasmas or flooding. We dike, drain, or fill them and have been doing so since Babylon. No wonder the poet, writing more than a century ago of a Scottish watercourse, wondered what the world would be without wildness and wet and pleaded for their continuance. In this bioregion since the European advent, two-thirds of historic Great Lakes wetlands have been remodeled to the vanishing point.

Excepting old growth trees and unbroken expanse, not much is missing from the Bete Grise (pronounced Bay Degree) Preserve. Its remoteness on the Keweenaw Peninsula, a claw of ancient rock jutting into the immensity of Lake Superior, has helped protect this last best Great Lakes marsh, bog, dune, and swale wetland complex.

Bete Grise is French for "gray or grizzled beast," so named, runs the speculation, because all winter long it's dark and gray and cloudy. Until recently Bete Grise was far enough away and its winters sufficiently grueling that this coastal wilderness hadn't been too hard used or heavily visited since being logged during the mining era.

An estimated billion board feet of timber went underground to frame the shafts and stopes of the mines. In the 1860s the Mendota Ship Canal cut a straight channel across the meanders that flowed from Lac La Belle into Bete Grise Bay to get shipping closer to the nearby copper mines and to give mariners on monstrously capricious Lake Superior ready access to a safe harbor.

Running southeast from the mouth of Lac La Belle along the shoreline of Bete Grise Bay, the preserve is an astonishingly rich thousand-some acres. An aerial view shows clearly how postglacial Lake Superior's gradually receding waters left dozens of ripples echoing earlier shorelines in the form of beach ridges, with wet swales, each a singular environment, behind them.

STEPHANIE MILLS *The Gray Beast: All Wildness and Wet*

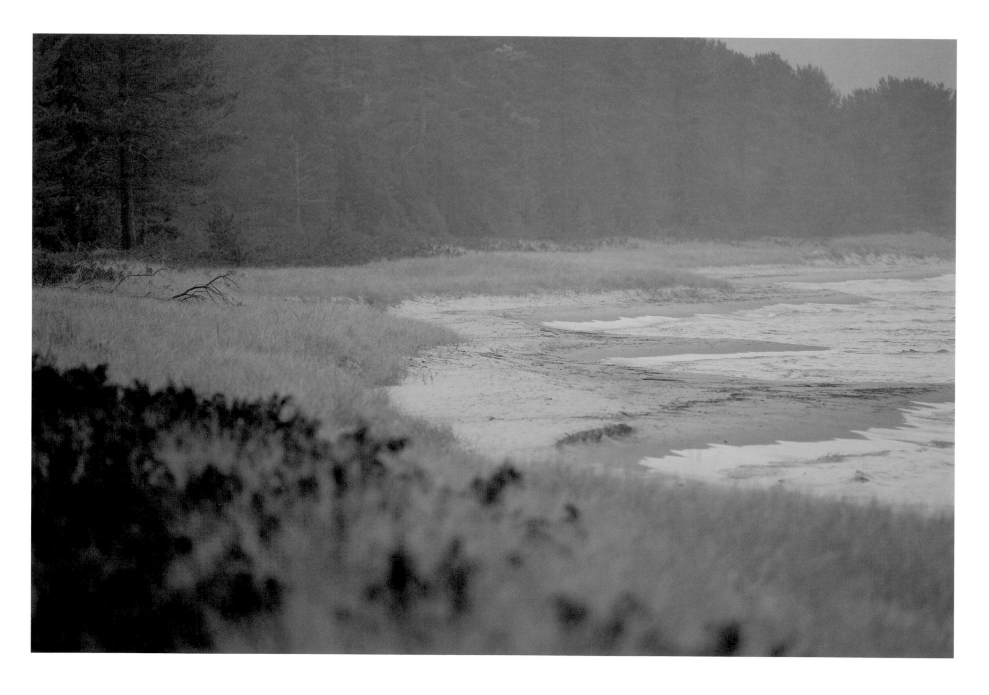

I have such fond memories of upper Michigan as a young boy. People look back at those days and ask "Why don't we have that any more?" Well, we can—if we just plan well and act now. ∞ Peter Wege

In addition to uninhabitable marsh, slough, dune, and swale, the Bete Grise Preserve includes a mile and a half of sandy shoreline. And these days an unspoiled beach on Lake Superior is an asset as lordly as a boulder of float copper.

〰〰

The plethora of names and varieties of wetlands connotes the elemental ambiguity in these fecund engagements of land with water. From wave-struck beach to quaking bog, wetlands are landscapes in flux where the habitat diverges with every declivity or bend in the slough. The myriad plants and animals whose lives intertwine in these many places can be quite particular in their preferences for sun and shade, cover and prey, alkalinity and oxygen.

A marsh is very wet—a treeless flooded wetland. Coastal marshes are fish nurseries. They're the very basis of the Great Lakes ecosystem and a fishery that was once among the finest in the world. Bald eagles, sandhill cranes, loons, and other waterfowl are among the birds that need this fluent, variegated terrain for their posterity. Moose and black bear also find wetlands to their liking.

Rich in flora, the Bete Grise Preserve abounds in rushes (seven species identified so far), sedges (twenty-five species and counting), orchids (six at least), grasses, and carnivorous plants including sundew, bladderwort, and pitcher plant. Citing quantities of species and botanical curiosities barely hints at the great reality of this place. It is not full of life merely, for a petri dish with a growing staph culture is that, but full of a wild variety of lives, all belonging right here.

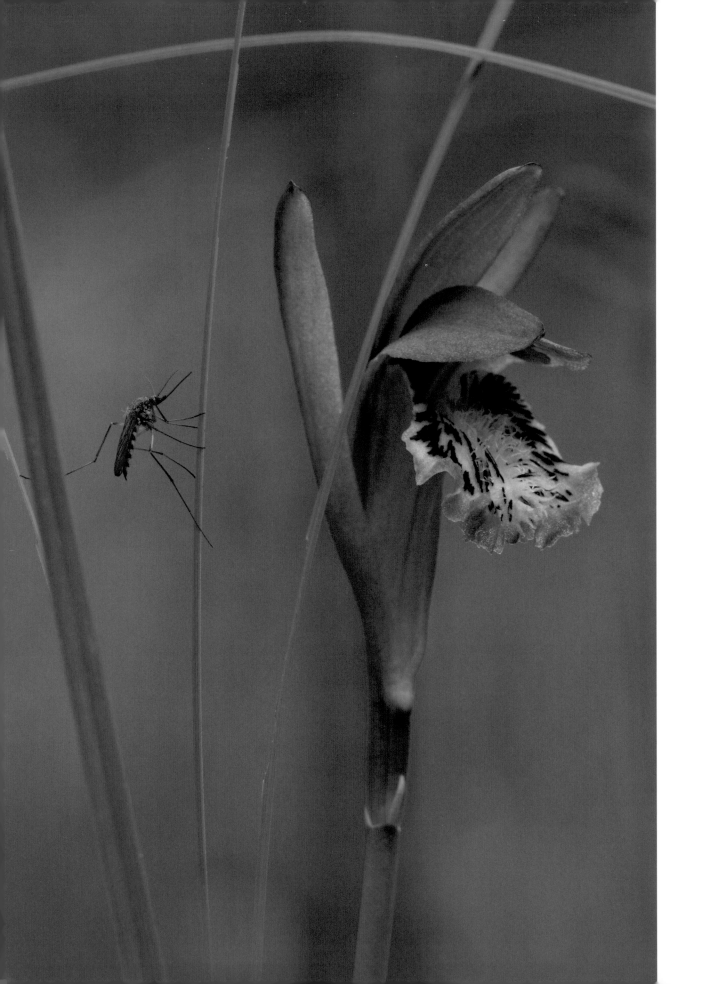

In late July of 2006, little more than a year after the Bete Grise Preserve was dedicated, Doug (my sidekick for the day) and I met Gina, a local volunteer, and her seven-year-old son Nick at the preserve parking lot. Gina, one of the preserve's many champions, took a morning to show us around. Doug, a champion of wildness throughout the Upper Peninsula, and I were glad to begin our day's tour with a walk north along the shore. It was a bonny day with barelegged warmth and breezes foiling the stable flies that ordinarily torment Lake Superior beachgoers.

On Bete Grise beach the sand was firm; the bay's waters sparkled as we strolled toward the canal and the Mendota Lighthouse. North of the Mendota Canal, a second-home development occupies the beach and inland dunal landscape. South of the canal, much of what is now the Bete Grise Preserve had once been staked for a similar fate.

Acquisition of this property from International Paper took several years of partnership building, skillful negotiation, and diligent grant writing on the part of all the people in "the Big We"—the partnership of The Nature Conservancy, the Keweenaw Land Trust, the Houghton-Keweenaw Conservation District, the South Shore Homeowner's Association, the U.S. Fish and Wildlife Service, the Michigan Department of Environmental Quality, the National Oceanic and Atmospheric Administration, and the Michigan Department of Natural Resources. Without their concerted efforts, taking such a walk might have become an exclusive privilege.

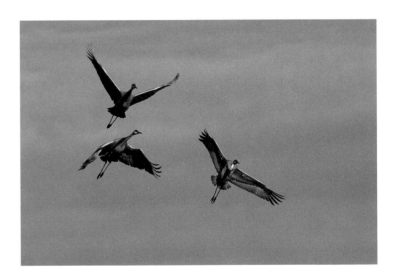

A few yards upland the sunlit grasses nodded in the wind. They joined a carpet of bearberry, trailing arbutus, and an abundant but unfamiliar delicate white flower in rooting a stable terrain. Still farther inland, white and red pines loomed above, shading low-lying blueberry bushes just bearing fruit. Gina flowed like light honey along a familiar, but little-trod path. Her son, tawny with summer, gamboled, in and out of the water, coursing ahead through the pines and heath, then down to the shore and into the lake.

Ojibwa traditionally came to Bete Grise for summer food

gathering. Berrying here was traditional with settlers and their descendants, too. Today with every other step Gina gracefully picked a few blueberries to offer to her son.

"What's your favorite thing about this place?" I asked Nick.

"You can eat it," he said.

~~~

Sea kayaks allowed us to venture into the marsh. We paddled past the few private holdings on the inner waterway. Here and there were tots on the shore and motorboats at their docks.

We turned into a transparent slough with tea-colored water, plying a channel through a wet meadow. In contrast with most wetlands, here were not the familiar solid masses of cattails, loosestrife, or *Phragmites* reeds but all those aforementioned rushes, sedges and grasses, head high, lush, and varied as old growth forest or unbroken prairie.

How many kinds of courtship, mating, spawning, pollination, fertilization, gestation, germination, hatching, flowering, metamorphosis, capture, devouring, and decomposing were going on, uncompromised and unhindered as our two human lives glided past?

A scatter of coppery pine flowers drifted on the water. Different *Potamogeton*, or pondweeds, rippled within the stream. Tiny darting fish seemed to appreciate their cover. Mature red pines with their tidy sprays of needles complemented the rangy, wolfish whites and denoted the high ground. Inward, tamarack and black spruce showed their muskeg fondness for rooting in the mere. Dark in the distance loomed green mountains—600-million-year-old rock, wearing

a north woods forest, an ecosystem dating from the last glacial retreat an eyeblink 10,000 years ago.

Although at sufficient scale, and over longer than human life spans, wild ecosystems can be supple and enduring, in the here and now they are terribly vulnerable. You don't need a front-end loader to compromise or annihilate a Bete Grise. A few knapweed seeds caught in your lug soles or a sprig of Eurasian water milfoil caught on a propeller can launch an invasion capable of reducing such lush biodiversity to ecological slag. At the preserve's parking lot the friends of Bete Grise have already had their first knapweed pull, trying to thwart the incursion of this demonic weed.

Still, out of respect for local residents who have long fished here and enjoyed the beach, and because the grants the Big We obtained to purchase the land require public access, the Bete Grise Preserve is open to nonmotorized daytime visitation. While overnight camping is not permitted, kayaking, canoeing, and fishing in the sloughs are, and, of course, berry picking.

It was wondrous to hear sandhill cranes trumpeting and see an eagle's nest and to glimpse some of the nuances of wetland. Bete Grise, however, is the kind of place a flatlander like me might hope to visit once or twice, but gently. Lucky its neighbors to live by a landscape of hope! How grateful we may be for the work and care it's taken to let this extraordinary place be left. Yet much remains to be done in our hearts and ways of being so that it and places like it may live long—and not leave the world bereft. ∞

Michigan continues to be blessed with unmatched natural beauty and a treasure trove of wildlife, forests, lakes, and rivers. It is our duty to make sure this incredible heritage remains available for future generations to love and enjoy. ∞ Governor John Engler

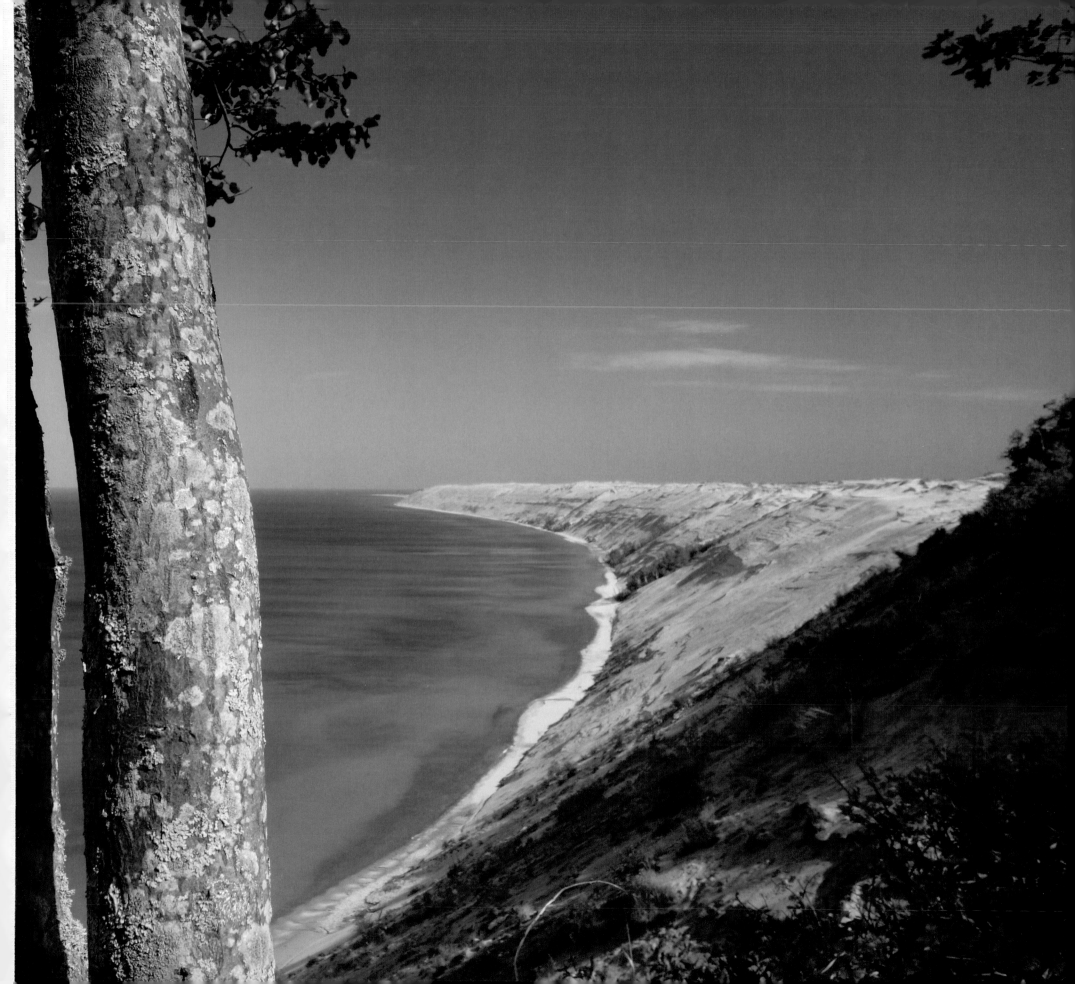

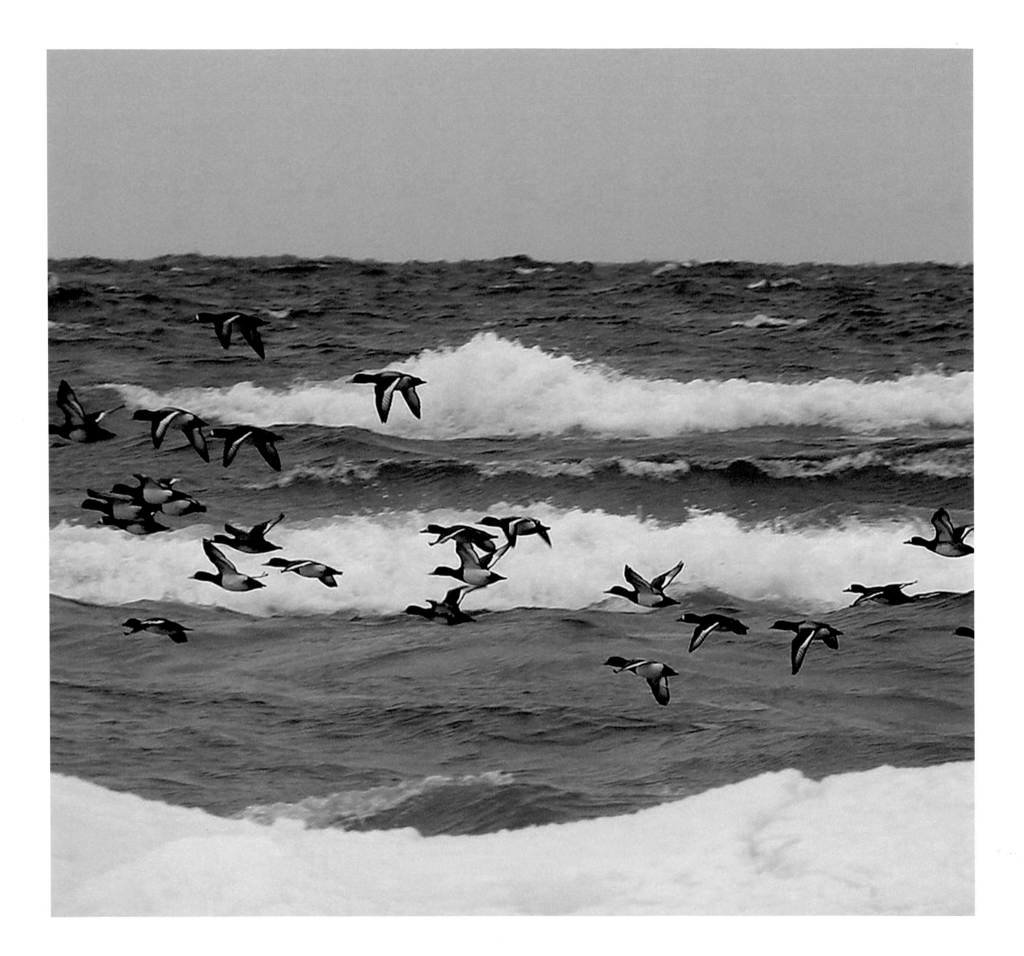

When the wind is up—and the wind is often up—Point Betsie is a quieting place. I don't mean that it is without noise, for on this shallow point, exposed to three of the four quarters of Lake Michigan's winds, there is much wave clamor and wind howl. I mean it quiets us. Even when we are determined to make ourselves heard, we have little voice in the matter. The wind outshouts us every time.

When I was a kid, Point Betsie marked the southern boundary of my home turf. My family and I spent many days every summer exploring the beaches from there to Platte Bay and around Sleeping Bear Point to Glen Arbor. In late August and into September my father, mother, brother, and I fished for salmon in Platte Bay, sometimes trolling as far as Point Betsie but never beyond it. Like countless lakefarers before and since, we relied on the point and its lighthouse as a landmark. We could triangulate it with the flank of Sleeping Bear and the notch in the forest where the Platte River enters the lake and know where to begin setting our lines. And, like so many others before us, we took comfort in knowing the light's beacon was there when we needed it.

In those days, as now, a few hours on the open lake was enough. Although I loved to fish, I was always glad when we beached at midday to eat lunch and explore the shore. After storms, especially, the beach held treasures: brightly colored fishing lures lost by fishermen, the bleached carcass of a salmon or lake trout, monarch butterflies that had been caught by waves during their migrations south. Even more interesting to me were the dunes. I followed the narrow trails of sand through the marram grass, with its razor edges, to protected swales among the dunes and shallow ponds where I could wade in search of frogs and turtles. Farther in were dense islandlike thickets of aspens and spruces where songbirds flitted in the shadows.

The dunes that line much of the eastern shore of Lake Michigan form the largest system of freshwater dunes in the world. That they have been under siege is no secret. They have been built upon, excavated into harbors, bulldozed level to make room for subdivisions, and mined for sand that is used in the casting of engine blocks and other products. Many of the dunes at the southern end of Lake Michigan were long ago shoved aside to make room for industry, most dramatically for the steel mills of Gary and South Chicago, most of which have since failed, leaving a wasteland of rusting desolation in their place.

A different kind of desolation threatens the dunes farther up the shore in Michigan, though with equally irreversible

JERRY DENNIS *Point Betsie*

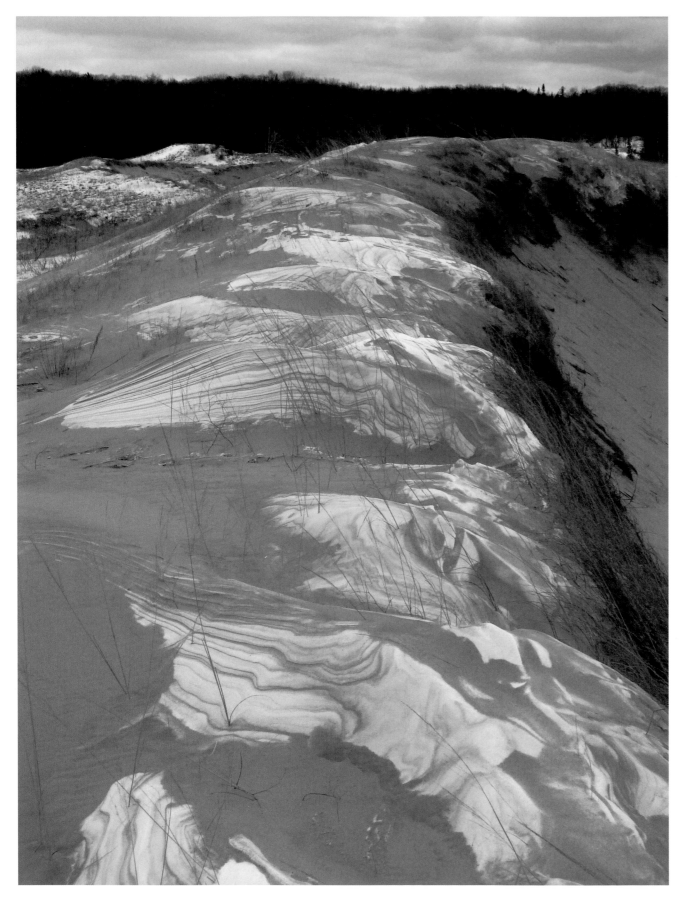

> **It is very human to be moved by place, by something larger than yourself. It is part of how we relate to each other in Michigan—our common attraction to nature. These places need champions.**
>
> ∞ Lana Pollack

consequences. People want to live on the water—who can blame them?—and many miles of former dunes have been sacrificed to make way for summer homes and cottages situated to take best advantage of the sunset view.

It's to our credit that some of the most beautiful dunes and shoreline have been preserved in state and national parks and other forms of public ownership. We're fortunate, for instance, that the Zetterberg family from California began purchasing land at Point Betsie in 1927. We're more fortunate still that in 1988 the family donated some 70 acres of virgin dunes and shoreline to The Nature Conservancy. If the property had been made available on the open market, it would surely have stirred a frenzy of development. Beachfront developments packed with condominiums and townhouses are the steel mills of the north, speculators the titans of industry. The land would have been closed off for the benefit of a few, and a landscape unique in the world, along with the plants and animals that evolved over millennia to live there, would have been lost.

Because of the foresight of the Zetterbergs, this section of shore and dunes has changed little in more than half a century. But that is not to say that it is untouched by humans. On a recent June morning, John and Lara from The Nature Conservancy led my wife and me on a hike through the dunes and along the shore of the Zetterberg Preserve. They showed us first the work the Conservancy has done in conjunction with volunteers from Americorps, under Lara's supervision, to control the invasive plant commonly known as baby's breath. An innocuous-seeming plant of the genus *Gypsophila* (mean-

ing "sand loving"), it is native to the shores of the Black Sea and is similar in appearance, when desiccated, to the tumbleweed of the southwestern deserts. It is widely used in floral arrangements and is often dried, bound into bunches, and offered for sale. But "this pernicious nuisance species," as John called it, has a powerful and deep-reaching taproot and the habit of profuse seeding, both of which allow it to get a firm grip in an ecosystem and dominate it, crowding out native plants. Point Betsie is thought to be home to the source population of baby's breath in the Great Lakes region, where it was probably first planted to be used in the floral trade. Its seeds, carried north and east by the wind, accumulate against forest walls and the lee sides of dunes and bluffs and are steadily making their way north and east. The plant is making inroads into nearby Sleeping Bear Dunes National Lakeshore and has been found as far north as Petoskey, about 100 miles away.

As we stood in a swale dominated by the invasive plant, John explained that until a selective herbicide is perfected the only way to control it is through "grunt work." He demonstrated how to drive the flat blade of a shovel deep into the sand until it nudges the side of the taproot, then shoved his heel against the blade and sliced through the rutabagalike root. "One down," he said. "A couple million to go."

Nearby was a pair of monitoring plots, their 10-meter boundaries marked with lengths of PVC pipe driven into the sand. Since 1990 researchers have studied the plots to learn what effects baby's breath, spotted knapweed, and other invaders have on native plants.

John and Lara then gave us a minicourse on forest succession—the ways in which bearberry, creeping juniper, and mosses naturally stabilize the backdunes and eventually give way to boreal pockets of spruce, fir, and pine. Closer to shore they identified other natives: hoary puccoon, ragwort, wormwood, broomrape, marram grass.

"Here's one you might find surprising," he said, kneeling to point at a small clump of grass. "Little bluestem." When I asked if it was the same grass that once thrived in such abundance on the prairies, he confirmed that it was and added that dunes and prairies share an "ecological affinity."

The dunes around Point Betsie are parabolic, named for their boomerang shape, and appear to roll, like ocean swells, inland from the lake. They lack the dramatic size of the high-perched dunes farther up the shore at Sleeping Bear, which sit atop ancient glacial moraines. Parabolic dunes form on unstable sand, and thus they are in constant migration and subject to frequent blowouts. Scattered among them we found interdunal wetlands and ponds where a greater diversity of plants and animals can be found than elsewhere in the dunes.

We kneeled to examine specimens of Pitcher's thistle, a threatened species that is particularly abundant in the Zetterberg Preserve. The thistle is vulnerable because it requires two to eight years to mature before blossoming for a couple of weeks one summer, then dying and scattering its seeds in a close circle around it. Evolved to live only in Great Lakes dunes, Pitcher's thistle is at risk from shrinking habitat and human foot traffic. We stepped carefully as we made our way among the thistles, and I couldn't help noticing our footprints, left deep in the sand, along with those of many people who had been there before us.

There's little chance that this popular preserve along the Lake Michigan shore will ever be free of such footprints. I'm not sure it should be. We need small wild places where the wild exists side by side with the civilized. For most of Western history we've insisted that nature and culture are opposites, separated by clear boundaries. But in places like Point Betsie the boundaries blur. And that's good. The boundaries *should* blur. They're porous, after all. Examine them up close and you can see that there is no clear delineation between natural and artificial, between inside and outside, between self and world.

When the wind is up, you can stand on the shore of Point Betsie and watch whitecaps charge the shore. Each wave, as it approaches shallow water, rises, grows steeper, reaches a peak, and throws itself roaring on the beach. The roar is the very sound of the earth being changed. One of the wonders of the place is that it is constantly changing while changing very little at all. ∞

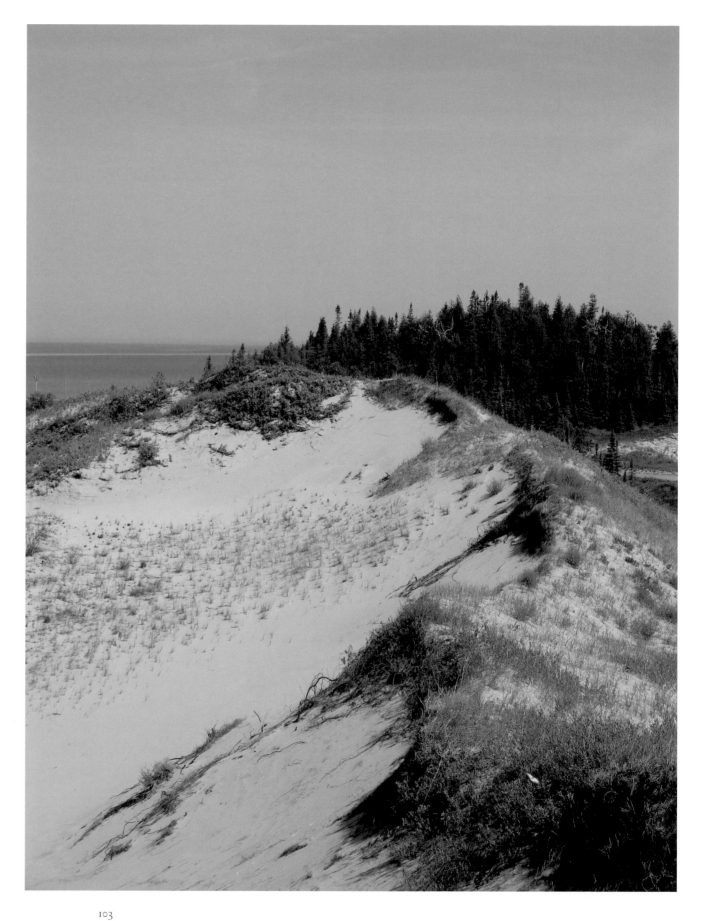

*Dennis   •   Point Betsie*

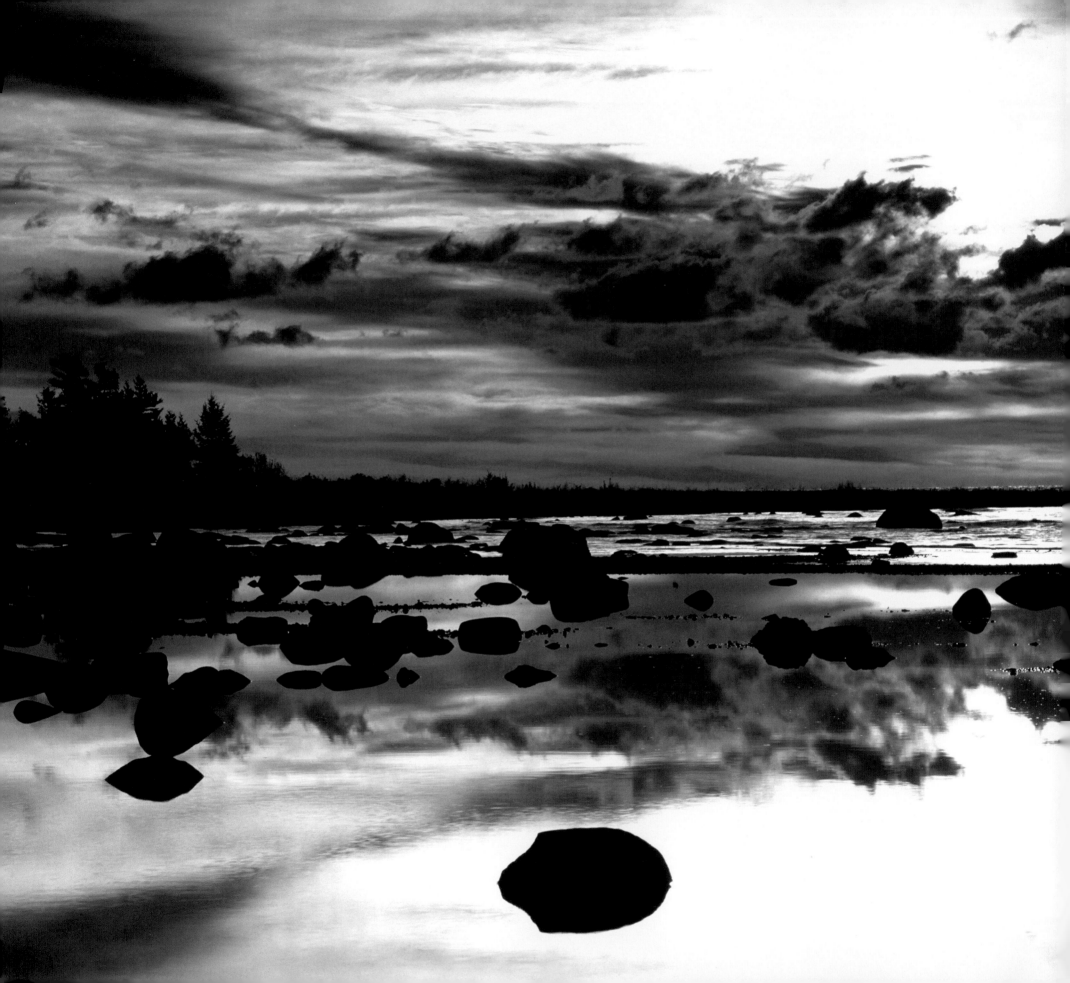

My childhood and adult years have been inextricably woven with woods, water, and shore-line. I look out on Grand Traverse Bay the first thing each morning. All of these natural wonders are part of me, and if I am able to leave any kind of legacy, part of it would surely be to help imprint an appreciation of these wondrous elements of nature—to inspire each of us to consider himself a steward. The natural beauty of our great state of Michigan is fragile and irreplaceable. It depends upon our ongoing care and commitment. The Nature Conservancy has proven itself an indispensable guardian and conservator of our land and its treasures. ∽ Governor William Milliken

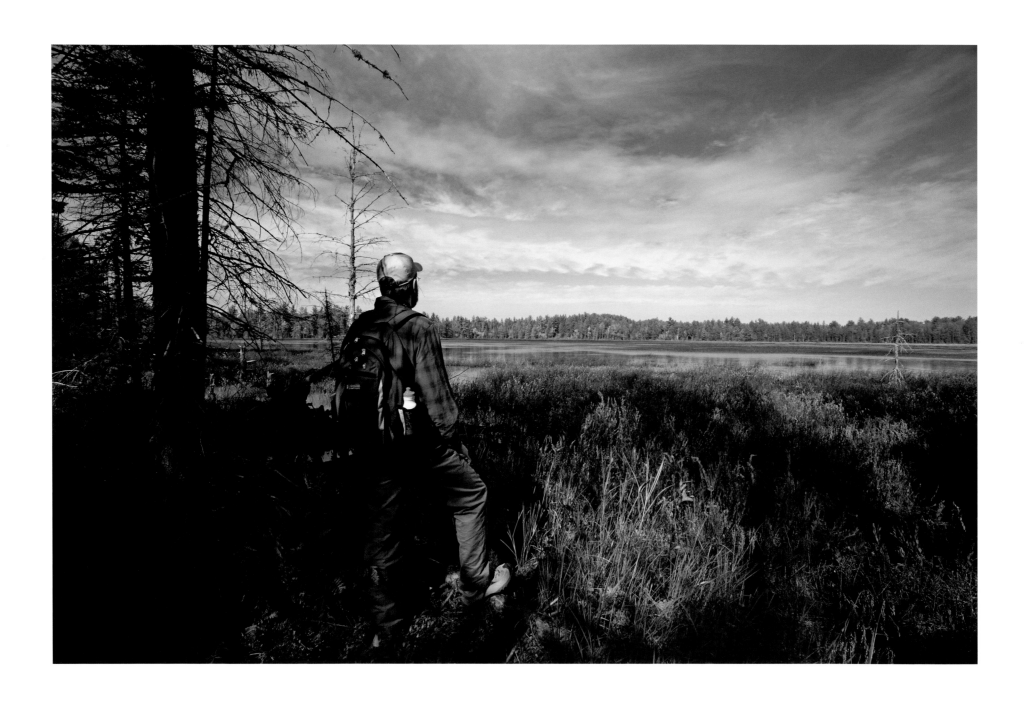

**Jerry Dennis's** books about nature, including *The Living Great Lakes: Searching for the Heart of the Inland Seas,* have been translated into five languages and have received numerous awards. He is currently working on a book that explores our changing relationships with the natural world.

**Jack Driscoll's** latest novel is *How Like an Angel,* a Michigan Notable Book and a finalist for the Great Lakes Book Award. He is currently writer-in-residence at the Interlochen Center for the Arts and teaches fiction workshops in Pacific University's low-residency master of fine arts program in Oregon.

**Janet Kauffman** lives in Hudson, Michigan, where she has restored wetlands on her farm and works for watershed protection with Environmentally Concerned Citizens of South Central Michigan and the Bean/Tiffin Watershed Coalition. Her most recent books include a novella, *Rot,* and a collection of prose poems, *Five on Fiction.*

**John Knott's** books include *Imagining Wild America* and *The Huron River: Voices from the Watershed* (coedited with Keith Taylor). He is Professor Emeritus of English at the University of Michigan.

**Elizabeth Kostova** has published fiction, poetry, and essays. Her first novel, *The Historian,* is being translated into forty languages. She has strong interests in travel writing and environmental issues.

**Howard Meyerson** is an award-winning reporter and photographer with twenty-four years of experience writing about outdoor recreation, the environment, and natural resources. He is the outdoors editor for the *Grand Rapids Press.*

**Stephanie Mills** is the author of *Epicurean Simplicity, In Service of the Wild,* and scores of articles and essays appearing in publications ranging from *The Britannica Book of the Year* to *Glamour.* She lectures throughout the United States and occasionally abroad and has lived on Michigan's Leelanau Peninsula for more than twenty years.

**Anne-Marie Oomen** is the author of *Pulling Down the Barn* and *House of Fields,* both Michigan Notable Books, and *Uncoded Woman,* a collection of poems. She serves as Chair of Creative Writing at the Interlochen Arts Academy and is a nonfiction instructor for the Solstice Conference of Pine Manor College in Massachusetts.

**Alison Swan** is the editor of *Fresh Water: Women Writing on the Great Lakes,* a creative nonfiction prose collection. Her poems and prose have appeared in many publications, including *Peninsula: Essays and Memoirs from Michigan.* In 2002, she and her husband, David Swan, were cowinners of the Michigan Environmental Council's Petoskey Prize for their efforts to protect Saugatuck Dunes State Park.

**Helen Taylor** has spent the last two decades working on Great Lakes protection, policy, and conservation. She joined The Nature Conservancy in 1996 to lead its Great Lakes Program, and since 1999 has served as State Director of its Michigan program. Helen and her husband, Dean Bolton, and two sons, Lowell and Miles, spend every spare minute they can enjoying Michigan and the Great Lakes.

**Keith Taylor's** most recent books are *Guilty at the Rapture,* a Michigan Notable Book for 2007, and *Battered Guitars: The Poetry and Prose of Kostas Karyotakis,* of which he was the cotranslator. He teaches creative writing at the University of Michigan and environmental writing at the university's Biological Station near Pellston.

*Contributors*

We are grateful to the following individuals for sharing their personal thoughts and for setting an example by their leadership and their commitment to protecting the natural heritage of Michigan and the Great Lakes for future generations.

**Governor James Blanchard** was Michigan's forty-fifth governor, serving from 1983 to 1991.

**David Brandon** is Chairman of the Board and Chief Executive Officer and Manager of Domino's Pizza.

**Congressman John Dingell** is the U.S. Representative from Michigan's Fifteenth Congressional District, elected in 1955. He is the second longest-serving member of the House of Representatives and the fourth-longest-serving member of Congress.

**Governor John Engler** was Michigan's forty-sixth governor, serving from 1991 to 2003.

**William Clay Ford Jr.** is Executive Chairman of the Board of Directors of the Ford Motor Company.

**David Frey** is Chairman of the Frey Foundation.

**Governor Jennifer Granholm** is Michigan's first female governor, serving from 2003 to the present.

**Senator Carl Levin** has served as a U.S. Senator from Michigan since 1979.

**Richard Manoogian** is Executive Chairman of the Masco Corporation.

**Hank Meijer** is Co-Chairman of Meijer, Inc.

**Governor William Milliken** served as governor for fourteen years, from 1969 to 1983. He is Michigan's longest-serving governor.

**Bill Parfet** is Chairman and Chief Executive Officer of MPI Research in Mattawan, Michigan.

**Roger Penske** is Chairman of the Penske Corporation.

**Lana Pollack** is President of the Michigan Environmental Council.

**Philip H. Power** is Founder and President of the Center for Michigan and served as Chairman of the Michigan Board of Trustees of The Nature Conservancy from 2003 to 2007.

**Margaret Ann Rieker** is President of the Herbert H. and Grace A. Dow Foundation.

**Rick Snyder** is Chief Executive Officer of Ardesta LLC.

**Senator Debbie Stabenow** is Michigan's first female U.S. Senator, serving since 2001.

**Peter Wege** is the founder of the Wege Foundation.

Frontispiece
  Misery Bay, Alpena County
  **Michael D-L Jordan**

v Nan Weston Preserve at Sharon Hollow,
  Washtenaw County
  **Michael D-L Jordan**

vi Shore grasses, Lake Superior
  **Michael D-L Jordan**

viii Mary Macdonald Preserve at Horseshoe Harbor,
  Keweenaw County
  **Richard Baumer**

viii Great gray owl
  **Rick Baetsen**

ix Two Hearted River, Luce County
  **Michael D-L Jordan**

ix Fall foliage, Luce County
  **Michael D-L Jordan**

xi Tip of the Keweenaw Peninsula,
  Keweenaw County
  **Michael D-L Jordan**

xii Copper Harbor, Lake Superior
  **Michael D-L Jordan**

2 Common milkweed seedpod
  **Rod Planck**

4 Nan Weston Preserve at Sharon Hollow,
  Washtenaw County
  **Michael D-L Jordan**

6 Nan Weston Preserve at Sharon Hollow,
  Washtenaw County
  **Michael D-L Jordan**

8 Forest floor, Two Hearted River Forest Reserve,
  Luce County
  **Ron Leonetti**

11 Layered slate, Upper Peninsula
  **Bruce Montagne**

12 Swamp with red maple, Nan Weston Preserve
  at Sharon Hollow, Washtenaw County
  **Ron Leonetti**

14 River Raisin, Nan Weston Preserve at Sharon Hollow,
  Washtenaw County
  **Richard Baumer**

15 Scarlet tanager
  **Carl Freeman**

17 Skunk cabbage, Nan Weston Preserve at
  Sharon Hollow, Washtenaw County
  **Ron Leonetti**

18 Trillium, Nan Weston Preserve at Sharon Hollow,
  Washtenaw County
  **Ron Leonetti**

19 Yellow Morel Mushroom
  **Walt Fechner**

21 Grass Bay Preserve, Cheboygan County
  **Ron Leonetti**

22 Prairie smoke
  **Harold E. Malde**

*Photographic Credits*

24 New growth after controlled burn,
Ives Road Fen Preserve, Lenawee County
**Michael D-L Jordan**

25 Forest restoration through controlled burn
**Jack McGowan-Stinski**

27 Karner blue butterfly
**Andy Morrison**

28 Oak-Pine savanna prairie, Newaygo County
**Harold E. Malde**

29 Lupine grows after a prescribed burn,
Ives Road Fen Preserve, Lenawee County
**Michael D-L Jordan**

30 Paw Paw Prairie Fen Preserve, Van Buren County
**Michael D-L Jordan**

33 Eastern box turtle
**James Harding**

33 Pitcher plant
**Mark Carlson**

34 Sandhill crane
**Walt Fechner**

36 Blazing star, Paw Paw Prairie Fen Preserve
**Richard DeVries**

36 Wood frog, Nan Weston Preserve at Sharon Hollow,
Washtenaw County
**Michael D-L Jordan**

38 Two Hearted River, Luce County
**Michael D-L Jordan**

40 Shiawassee River Valley, Shiawassee County
**Michael D-L Jordan**

42 Morning on Lake Medora, Keweenaw County
**Michael D-L Jordan**

44 Two-stage ditch, Shiawassee County
**Michael D-L Jordan**

47 Rocks in the Shiawassee River, Shiawassee County
**Michael D-L Jordan**

48 Grasses, Misery Bay, Alpena County
**Michael D-L Jordan**

49 Shiawassee River in fall, Shiawassee County
**Michael D-L Jordan**

50 Snow trillium
**Michael D-L Jordan**

52 Two Hearted River Forest Reserve, Luce County
**Michael D-L Jordan**

54 Two Hearted River Forest Reserve, Luce County
**Ron Leonetti**

55 Black bear family
**Mark Carlson**

56 Garden Peninsula, Haunted Forest Preserve,
Delta County
**Michael D-L Jordan**

58 Ruffed grouse drumming
**Rick Baetsen**

59 White spruce, Luce County
**Michael D-L Jordan**

60 Mouth of the Two Hearted River, Luce County
**Michael D-L Jordan**

62 Garden Peninsula, Haunted Forest Preserve,
Delta County
**Michael D-L Jordan**

65 Grass Bay Preserve, Cheboygan County
**Ron Leonetti**

66 Erie Marsh Preserve, Monroe County
**Richard Baumer**

68 American lotus
**Ron Leonetti**

70 Misery Bay, Alpena County
**Michael D-L Jordan**

73 Erie Marsh Preserve, Monroe County
**Richard Baumer**

74  American lotuses, Erie Marsh Preserve,
    Monroe County
    **Ron Leonetti**

75  Snowy egret
    **Ron Leonetti**

77  Misery Bay, Alpena County
    **Ron Leonetti**

78  Carl A. Gerstacker Preserve at Dudley Bay,
    Mackinac County
    **Ron Leonetti**

81  Carl A. Gerstacker Preserve at Dudley Bay,
    Mackinac County
    **Ron Leonetti**

83  Carl A. Gerstacker Preserve at Dudley Bay,
    Mackinac County
    **Richard Baumer**

84  Les Cheneaux shoreline, Carl A. Gerstacker Preserve
    at Dudley Bay, Mackinac County
    **Ron Leonetti**

85  Reindeer lichen, Carl A. Gerstacker Preserve
    at Dudley Bay, Mackinac County
    **Matthew Bohan**

85  Black-throated green warbler
    **Walt Fechner**

86  Yellow lady slippers
    **Walt Fechner**

88  Bete Grise, Keweenaw County
    **Ron Leonetti**

90  Shoreline, Bete Grise Preserve, Keweenaw County
    **Michael D-L Jordan**

92  Arethusa orchid
    **Rod Planck**

93  Beach grasses, Bete Grise Preserve,
    Keweenaw County
    **Michael D-L Jordan**

93  Flying sandhill cranes
    **Mark Carlson**

95  Rock in water, Bete Grise Preserve,
    Keweenaw County
    **Michael D-L Jordan**

97  Pictured Rocks National Lakeshore, further protected
    through buffer lands managed by The Nature Conservancy
    **Michael D-L Jordan**

98  Mallards flying, Zetterberg Preserve at Point Betsie,
    Benzie County
    **Duane Krauss**

100 Zetterberg Preserve at Point Betsie, Benzie County
    **Duane Krauss**

102 Pitcher's thistle, Zetterberg Preserve at Point Betsie,
    Benzie County
    **Duane Krauss**

103 Zetterberg Preserve at Point Betsie, Benzie County
    **Duane Krauss**

104 Snake Island sunrise, Mackinac County
    **Richard Baumer**

106 McMahon Lake Preserve, Luce County
    **Michael D-L Jordan**

108 Nan Weston Preserve at Sharon Hollow,
    Washtenaw County
    **Michael D-L Jordan**

110 Shiawassee River Watershed
    **Michael D-L Jordan**

112 Fringed polygala, Carl A. Gerstacker Preserve
    at Dudley Bay, Mackinac County
    **Matthew Bohan**

114 Misery Bay, Alpena County
    **Michael D-L Jordan**

120 Lake Superior beach pebbles
    **Mark Carlson**

This book was published by
The University of Michigan Press
in cooperation with The Nature Conservancy.

Typeset in Fairfield and The Mix by
Savitski Design in Ann Arbor, Michigan.

Printed on 100-pound Sterling Ultra Matte.

Bound using Pearl Linen with Rainbow endsheets.

### ENVIRONMENTAL BENEFITS STATEMENT

**University of Michigan Press** saved the
following resources by printing the pages of this
book on chlorine free paper made with 10%
post-consumer waste.

| TREES | WATER | ENERGY | SOLID WASTE | GREENHOUSE GASES |
|-------|-------|--------|-------------|------------------|
| **6** | **2,301** | **4** | **381** | **702** |
| FULLY GROWN | GALLONS | MILLION BTUs | POUNDS | POUNDS |

Calculations based on research by Environmental Defense and the Paper Task Force.
Manufactured at Friesens Corporation

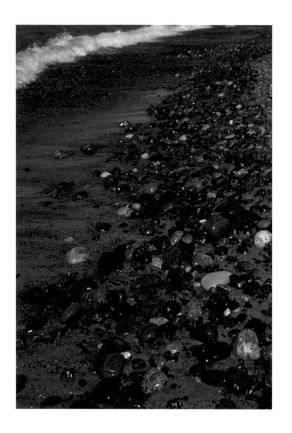